The College History Series

COLLEGE OF
SAINT ELIZABETH

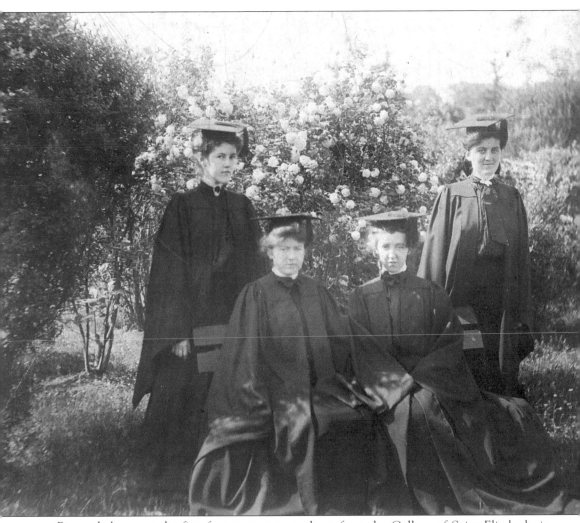

Pictured above are the first four women to graduate from the College of Saint Elizabeth, in 1903. (Family of Seton McCabe.)

The College History Series

COLLEGE OF
SAINT ELIZABETH

SISTER MARY ELLEN GLEASON, CAROL-MARIE KIERNAN,
AND GEORGE SIRGIOVANNI

ARCADIA

First published 1999.

Published by Arcadia Publishing,
an imprint of Tempus Publishing, Inc.
2 Cumberland Street
Charleston, SC 29401

Printed in Great Britain.

Library of Congress Catalog Card Number: 00-100391.

For all general information contact Arcadia Publishing at:
Telephone 843-853-2070
Fax 843-853-0044
E-Mail sales@arcadiapublishing.com

For customer service and orders:
Toll-Free 1-888-313-2665

Visit us on the internet at http://www.arcadiaimages.com

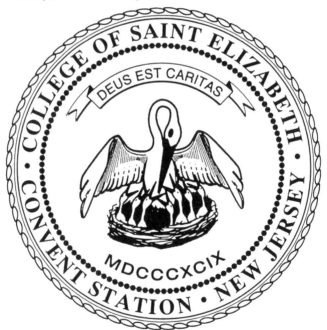

The pelican, the main feature in the College seal, is a Eucharistic symbol adopted by the Sisters of Charity and then by the College of Saint Elizabeth to symbolize an all-consuming dedication in carrying out an apostolic mission. Legend holds that the pelican, in times of famine, instinctively feeds her young with her own blood in order to save their lives. Inspired by this legend, the founders of the College of Saint Elizabeth chose the pelican to epitomize that spirit of charity and commitment, which would characterize all those associated with the College of Saint Elizabeth.

CONTENTS

ACKNOWLEDGMENTS

There are many people as well as offices who have provided invaluable assistance in making this pictorial history of the College of Saint Elizabeth a reality. To Sister Francis Raftery, President of the College of Saint Elizabeth; Sister Hildegarde Marie Mahoney, President emerita of the College of Saint Elizabeth; Sister Jacqueline Burns, President emerita of the College of Saint Elizabeth; Sister Blanche Marie McEniry, professor emerita; Sister Elizabeth McLoughlin, Director of Archives for the Sisters of Charity of Saint Elizabeth; Sister Elena Francis Arminio, Sister Anita Richard Heilenday, and Sister Agnes Vincent Rueshoff who made photographs available from their collections; Adult Undergraduate Degree Programs; Alumnae Association; Archives; Athletic Department; Center for Theological and Spiritual Development; Communications and Marketing Office; Office of Graduate Programs; Sandrian Studio; Centennial Steering Committee, and Co-Chairpersons Virginia McGlone and Eileen Fell; we express our deepest gratitude. We would also like to acknowledge the support of the Celebrating Our Heritage Centennial Committee: Sister Jane Cavanaugh, Betty Ann Clarken, Sister Kathleen Flanagan, Sister Patricia Flynn, Sister Mary Ellen Gleason, Sister Ann Haarer, Sister Ellen Joyce, Sister Mary Kapinos, Carol-Marie Kiernan, Dorothy McGuire, Carole Rogers, George Sirgiovanni, and Sister Marian José Smith.

Every effort has been made to credit photographs accurately. If an error has been made, we offer our apology. Revisions will be made in future editions.

INTRODUCTION

Founded in 1899 by the Sisters of Charity of Saint Elizabeth, the College of Saint Elizabeth (CSE) is the first permanent four-year liberal arts college for women to be established under either public or private auspices in the state of New Jersey. The college is among the first Catholic colleges in the United States to grant degrees to women.

The College of Saint Elizabeth was formally opened on September 11, 1899, with Sister Mary Pauline Kelligar as its first president. The freshman class included six members: one from New Jersey, one from Illinois, one from New York, and three from Massachusetts. Four members of the class were graduates of the Academy of Saint Elizabeth, located on the campus of the newly established college. Incorporated under New Jersey State law on May 29, 1900, the college granted its first baccalaureate degrees on June 18, 1903. There were four women in this first class: Mary Ennis, Esther Kenna, Blanche Maskell, and H. Seton McCabe.

From its origin to the present, the college has been a distinctly Catholic institution of higher education, welcoming students and employees of many religious traditions. By the wise foresight of the founders, the professional preparation of the Sisters appointed to the faculty has received paramount attention. From the very early years of the 20th century, the Sisters of Charity have obtained masters and doctoral degrees at many prestigious American colleges and universities, including Harvard, Yale, Chicago, Columbia, Fordham, and New York University.

During the early years of the college, the graduates of the college and academy established one alumnae association. As the number of graduates from both institutions steadily increased, distinct alumnae associations for the college and the academy were founded in November 1919. Since the spring of 1920, the College of Saint Elizabeth Alumnae Association has raised funds for scholarships, buildings, furnishings, and all anniversary celebrations held throughout the successive decades.

In 1905, the New York State Board of Regents notified the college of the registration of its degrees with that board, and in 1917, the Association of American Universities placed the College of Saint Elizabeth on its approved list of colleges and universities. Included among the accredited colleges listed by the Middle States Association of Colleges and Secondary Schools in its first official listing in 1921, the College of Saint Elizabeth has continually maintained such accreditation.

The college's programs involving teacher education, as described in its catalogs, are approved by the National Association of State Directors of Teacher Education and Certification. The upper division nursing program is accredited by the National League of Nursing and approved

by the New Jersey Board of Nursing.

The Foods and Nutrition major is approved by the American Dietetic Association (ADA) as a Didactic Program in Dietetics (Plan V) leading to the B.S. degree. The Dietetic Internship Program, a graduate certification program, also carries ADA approval.

In 1970, the college established a Continuing Education program to respond to the needs of older women seeking to complete interrupted degree programs or to update or augment their formal education. The press for "non-traditional age adults," both women and men, to obtain degrees while maintaining full-time employment led the college to initiate the Weekend College Program in 1976. In 1994, Continuing Education was renamed Continuing Studies, and the Adult Undergraduate Degree Programs were established, permitting the centralization of the Weekend College, Continuing Studies, and Nursing Programs and services offered to adult students.

In 1993, the college received approval from the New Jersey Board of Higher Education to offer a Master of Arts in Education: Human Services Leadership. The following year, this board approved the M.S. degree in Nutrition. The New Jersey Presidents' Council approved the M.A. in Counseling Psychology in 1994, as well as the M.A. in Theology and the M.A. in Educational Technology in 1995. Two additional programs were approved by the Presidents' Council in 1997: the M.S. in Health Care Management and the M.S. in Management.

Since its opening in 1899, the college has maintained its dedication to the development of leaders and to the full participation of women in society. There have only been six presidents in its history: Sister Mary Pauline Kelligar, Sister Mary Jose Byrne, Sister Hildegarde Marie Mahoney, Sister Elizabeth Ann Maloney, Sister Jacqueline Burns, and Sister Francis Raftery. These dedicated Sisters of Charity of Saint Elizabeth have provided outstanding leadership marked by faith, courage, and vision. The College of Saint Elizabeth Board of Trustees consists of the chancellor, who is the Bishop of the Patterson Diocese; the chairperson, who is the General Superior of the Sisters of Charity of Saint Elizabeth; the president-treasurer, who is the president of the college; the secretary, who is elected by the members; and additional members. These members are primarily responsible for establishing or approving general policies for the administration of the college, nomination of the president, and financial stability. The members are noted for devoting their time and resources to making the college a pre-eminent institution of higher education.

Today, 100 years and more than 10,000 graduates after its founding, the College of Saint Elizabeth remains strong, with a growing enrollment and a vital purpose. "The mission of the College of Saint Elizabeth is to be a community of learning in the Catholic liberal arts tradition for students of diverse ages, backgrounds, and cultures. Characterized by this strong Catholic identity and values, the College is committed to scholarship and critical inquiry. It fosters just and ethical relationships and the promotion of women as full partners in society in all its programs, including those which enroll both women and men. With quality teaching as a primary activity and the development of leadership in a spirit of service and social responsibility for others, the College promotes a caring, personal environment where students learn by example as well as by participation throughout their educational experience." As Mother Mary Xavier Mehegan and the other founders believed in the 1890s, we believe in the 1990s that the college will flourish and continue to provide a value-centered education that responds to society's needs in the 21st century.

One

1899–1909

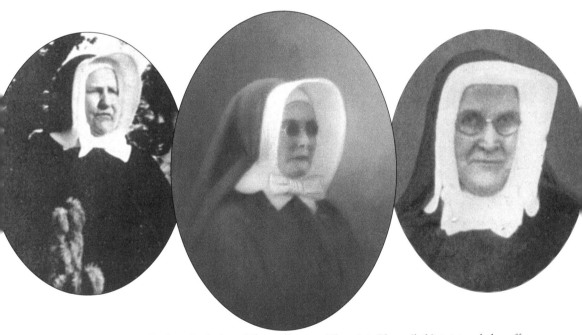

Sister Mary Agnes Sharkey (right) and Sister Regina Clare McClory (left) initiated the effort that would culminate in the establishment of the College of Saint Elizabeth in 1899. While teaching at the Academy of Saint Elizabeth, they received approval from the academy's directress, Sister Mary Pauline Kelligar, to ask Dr. Henry Taylor, director of Secondary Education of the New York State Board of Regents, about the feasibility of founding a college for women in New Jersey. Dr. Taylor reviewed the academy's curriculum and found that it was already providing "two good years of collegiate work." Encouraged, the two sisters pressed to have the Sisters of Charity of Saint Elizabeth support their idea of opening a college. Sister Mary Pauline Kelligar (center) would become the college's first president, a post she would fill for 23 years. For many of these years, she also served as the academy's director and as the mother assistant to the community—a remarkable feat of administrative stamina and ability. (Sisters of Charity Archives; CSE Archives.)

The sisters' proposal to found a college for women could not have been put into operation without the approval of the Most Reverend Winand Michael Wigger, Bishop of Newark, and of Mother Mary Xavier Mehegan (left). After carefully considering the ambitious project, Mother Xavier gave her consent in 1899. Seen below, Mother Xavier walks the grounds, accompanied by her dog, Captain. (CSE Archives.)

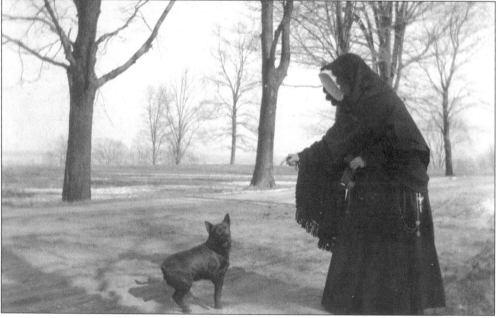

St. Elizabeth College

Convent Station, ❖ ❖ ❖ Morris County,
New Jersey

Announcements for 1899-1900

The school term, opening on Monday, September 11, 1899, promises to inaugurate a very successful year in the history of the institution. During the past year many improvements have been made, and the new wing, now in course of erection, will be devoted to the requirements of a full collegiate course of instruction ; the Academic and Preparatory Departments will be continued in the present buildings. Registration under the Board of Regents, University of the State of New York, was effected during the year, and every advantage is now offered to students who may wish to pursue the Teachers' Course, or follow one of the professions open to women.

Departments

Three distinct departments of study will be formed with the opening of the fall term, namely, the Preparatory, the Academic, and the Collegiate Course of Instruction.

Preparatory. Department

This department is for children (girls) of a tender age, who are classified according to their general standing. Pupils of this grade constitute what is known as the Primary and Grammar Courses of study. From this department they will be regularly advanced to the

Academic Department

As heretofore, students will be graduated from the Academic Department, and they may have their diploma registered by the Board of Regents. They may still further pursue their studies, entering, at option, either the Normal Course for Teachers, the Special Course in Music and Painting, or they may follow one of the Regular College Courses. All the students have access, at stated periods, to the gymnasium, tennis courts, etc., which have been fully equipped for their comfort and enjoyment.

Terms

Terms for the Preparatory and Academic Departments will be found in the accompanying prospectus. The terms for the College Department will appear in the Catalogue to be issued at the opening of the College building. Admission to the College Department will be based on the requirements for entrance into any college Freshman class.

With expressions of gratitude for many past favors, the Sisters earnestly solicit the kind co-operation of friends and patrons of the institution in behalf of the present undertaking, which has for its special object the higher education of women.

For further particulars and details of information, call at the College, or address,

THE MOTHER SUPERIOR,
Convent Station, New Jersey.

The college issued a set of official announcements for its opening year. Note that some of the announcements pertain to the academy and are indicative of the close relationship that existed between these two academic institutions.

Catalogue

OF THE

College of Saint Elizabeth,

Convent Station, (near Morristown,)

Morris County, New Jersey.

1903=04.

FOUNDED
1859.

ACADEMY OF SAINT ELIZABETH,
Charter Granted,
1863.

COLLEGE OF SAINT ELIZABETH.
Charter Granted,
May 29, 1899.

REQUIRED COURSES.

Freshman Year.

　Religion—*One hour a week.*
　Church History—*One hour a week.*
　Latin—*Four hours a week.*
　*Greek or French or German—*Four hours a week.*
　English—*Four hours a week.*
　Mathematics—*Three hours a week.*
　Hygiene—*One hour a week (First Term.)*
　　　　The one offered as second language at entrance.

Sophomore Year.

　Religion—*One hour a week.*
　Church History—*One hour a week.*
　English—*Two hours a week.*
　History—*Three hours a week.*
　Physics or Chemistry—*Three hours a week.*
　*French or German—*Five hours a week.*
　Three hours' elective work.
　　　　For those who offered Greek at entrance.

Junior Year.

　Religion—*Two hours a week.*
　Church History—*One hour a week.*
　Logic—*Five hours a week.*
　English—*Four hours a week.*
　*Biology or Geology—*Three hours a week.*
　Six hours' elective work.
　　　　For those who did not offer Science at entrance.

Senior Year.

　Philosophy—*Five hours a week.*
　Religion—*Two hours a week.*
　Economics—*Three hours a week.*
　Eight hours' elective work.

　All elective studies are subject to the approval of the Academic Board.

The college's initial curriculum offered a standard but rigorous program of courses for the time. (CSE Archives.)

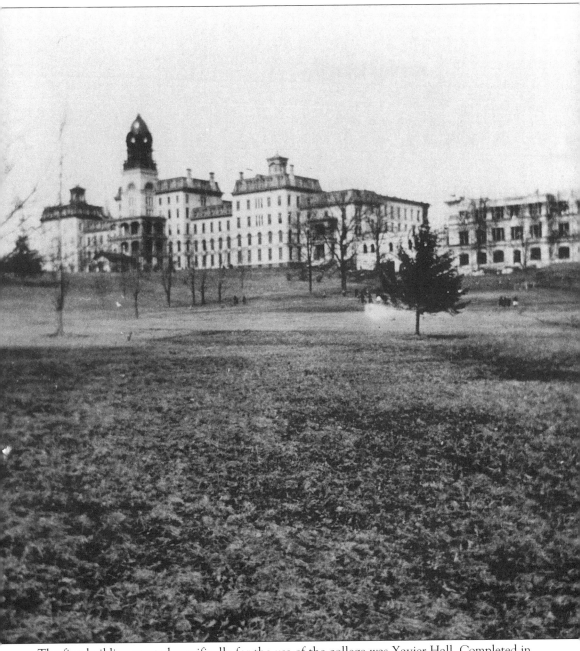

The first building erected specifically for the use of the college was Xavier Hall. Completed in 1901, this structure was connected to the large Administration Building, which the college shared with the academy. Over Mother Xavier's protests, the new building was named in her honor. (Sisters of Charity Archives.)

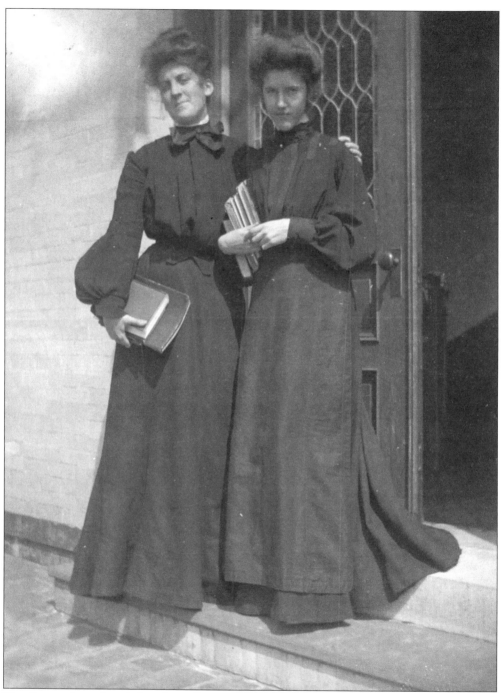

The first students found that the college provided a challenging and intellectually rewarding program of study. Shown above are two students from the first graduating class: Seton McCabe (left) and Esther Kenna (right). (Family of Seton McCabe.)

ONE OF FIRST FOUR TO RECEIVE A. B. DEGREE FROM ST. ELIZABETH COLLEGE

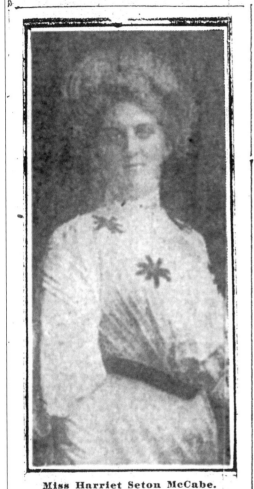

Miss Harriet Seton McCabe.

Miss H. S. McCabe, of This City, Also Awarded Gold Medal.

AT HEAD OF CLASS IN HISTORY

Miss Harriet Seton McCabe, one of the four young women upon whom the degree of A. B. was conferred by the College of St. Elizabeth at Convent Station last week, is the daughter of the late Owen McCabe, of this city. The degrees were awarded last Thursday for the first time in the history of the institution.

Miss McCabe received her primary education at St. James's Parochial School, which she left at an early age to pursue her studies under the direction of the Catholic sisters at Convent Station. She has invariably stood high in all of her classes, and at her graduation was the recipient of a gold medal for excellence in history. Miss McCabe is the seventh of the daughters of the late Owen McCabe to graduate from a school under the direction of the Catholic sisters.

A local newspaper found Seton McCabe's graduation from the college a newsworthy item. (Family of Seton McCabe.)

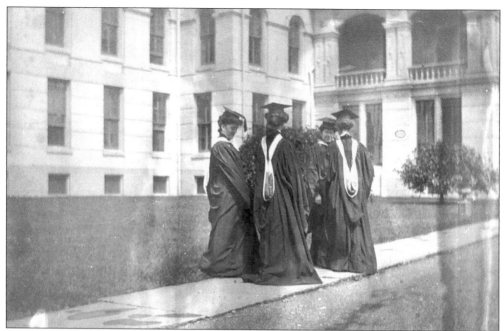

Standing in front of the Administration Building on Graduation Day 1903 are the members of the College of Saint Elizabeth's first graduating class. (Seton McCabe Family.)

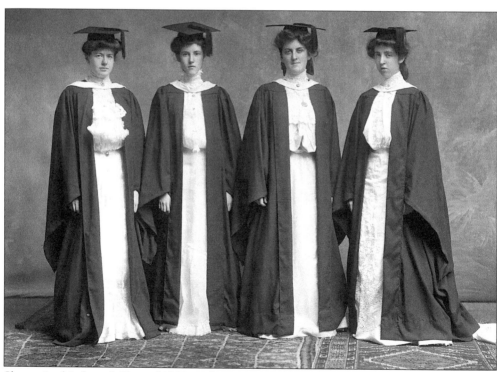

Shown in this formal Class of 1903 graduation portrait are, from left to right, as follows: Mary Ennis, Esther Kenna (later Sister Esther Maria), Seton McCabe, and Blanche Maskell (later Sister Blanche Marie). (CSE Archives.)

Address

Delivered by

His Lordship, the Right Rev. John J. O'Connor, D. D.,

on the

Occasion of the First Conferring of

Degrees

at the

College of Saint Elizabeth,

Convent Station,

New Jersey.

June, 1903.

In 1901, the Reverend John J. O'Connor was named Bishop of Newark, and he became a college trustee. Until his death in 1927, Bishop O'Connor was an unfailing advocate of the College of Saint Elizabeth. (CSE Archives.)

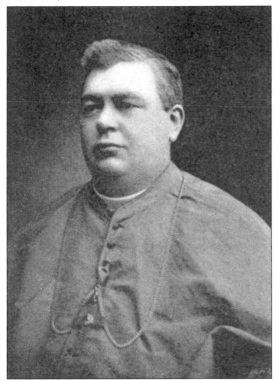

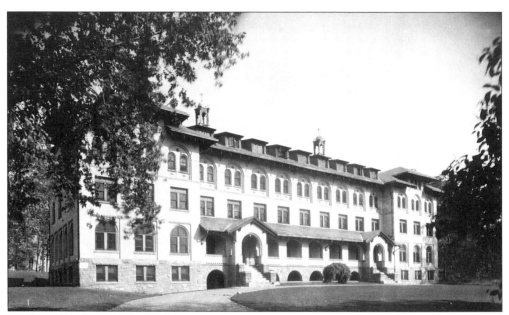

As the college's student population began to grow, the need for a dormitory building became paramount. Santa Rita Hall, the first campus building to be completely detached from the Administration Building, opened in 1907. The new building was named in honor of Saint Rita, whose intercession was implored for the healing of an injury to Mother Xavier's leg. With its attractive Spanish-style architecture, Santa Rita housed bedrooms, reception rooms, the Athletic Department, and the original college store. (CSE Archives; Sisters of Charity Archives.)

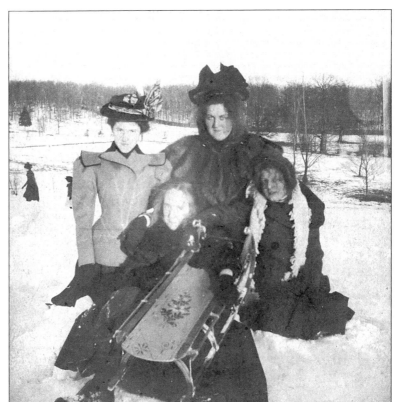

Although classes and studying took up much of their time, the students of the college's first decade, like their successors, found time for recreation and amusement. (Family of Seton McCabe.)

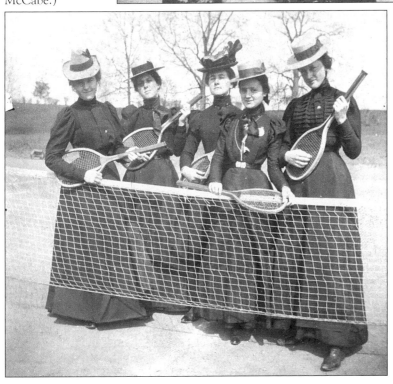

Four CSE student-actors pose in costume. Play productions were a vital component of the college's co-curricular life. (CSE Archives.)

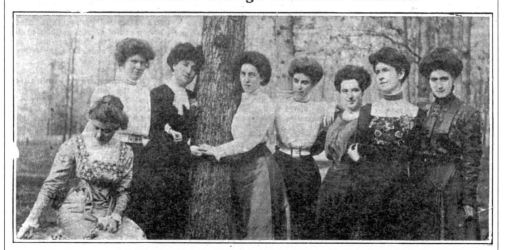

St. Elizabeth's College Alumnae Reunion

The Alumnae from left to right are: Miss Alice G. Bour, Ohio; Miss Corrinne M. Jennings, New York; Mrs. Maurice Brill, New York; Miss Alice C. Hyland, Brooklyn; Miss Mary Flannery, Brooklyn; Miss Josephine M. McMullen, Summit, N. J.; Mrs. Louise Horgan Griffin, Albany, and Miss Josephine T. Hinchliffe, Paterson. (See page 13.)

The college had a successful first decade, as indicated by the sizeable number of attendees at the early Saint Elizabeth's College Alumnae Reunion pictured above. (CSE Archives.)

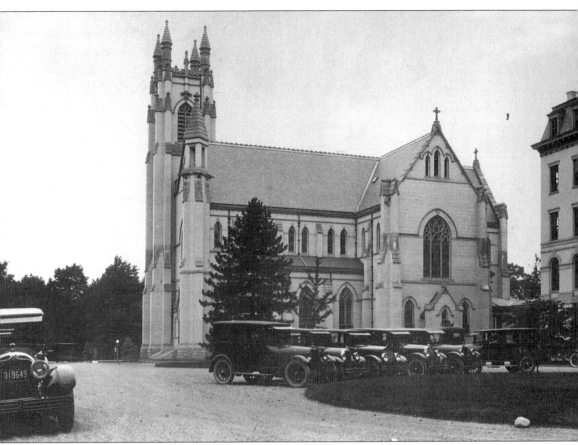

Holy Family Chapel is the center of worship on the campus. The dedication of the chapel took place in 1909, as the Sisters of Charity celebrated the 100th anniversary of their founding in the United States by Saint Elizabeth Ann Seton and the 50th anniversary of their foundation in the Diocese of Newark. (CSE Archives.)

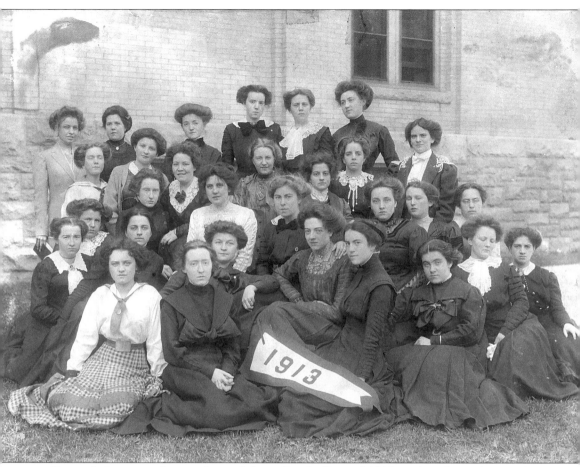

Pictured above are the members of the college's Class of 1913, gathered together in their freshman year of 1909. The size of this class confirms the rapid success attained by a group of devout and determined educators, the Sisters of Charity of Saint Elizabeth. (Florence Wall Collection.)

Two
1910–1919

In 1911, the college built a botany experiment station under the inspired direction of Sister Helen Angela Dorety, Class of 1904 (right). This greenhouse rested on the site just below the hill on which Santa Maria is located. Pictured at left is a blessing of the greenhouse sundial. (CSE Archives; Sisters of Charity Archives.)

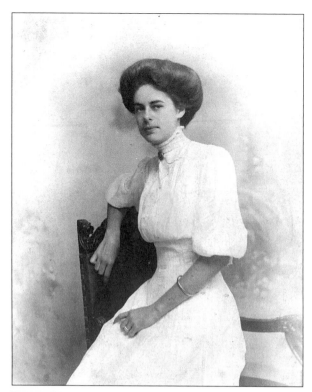

Florence Wall, Class of 1913 (left), —a chemist, cosmetologist, and extensively published researcher— was one of the college's most talented and accomplished lay alumnae. The photograph below is of a scene from a campus production of the morality play, *Every Freshman*, which she wrote as a CSE student. (Florence Wall Collection.)

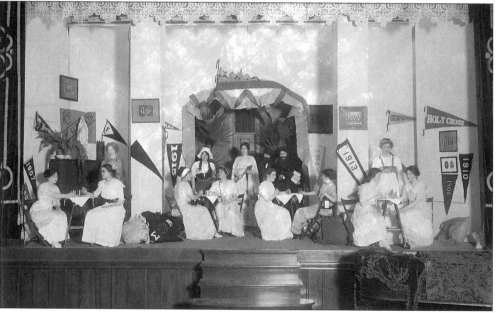

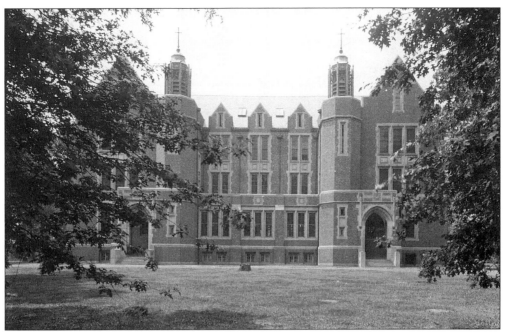

The land on which Santa Maria is built originally belonged to the Harpers of Harper Publishing. The Sisters of Charity bought this property from the Harpers for $4,000 in 1909. Built in English gothic style, Santa Maria opened in 1913, and housed classrooms, the library, laboratories, a lecture hall, and a basement clubroom (seen below) that was the meeting place for the Franco-German Club and later the International Club. Later still, it served as the periodical room of the library. (CSE Archives; Sisters of Charity Archives.)

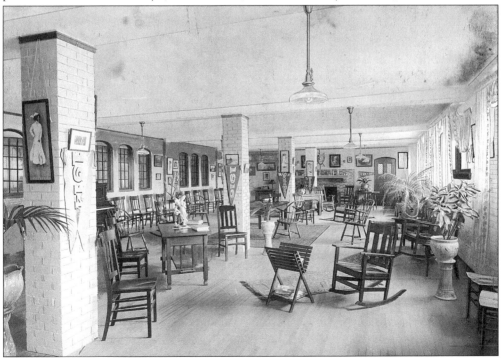

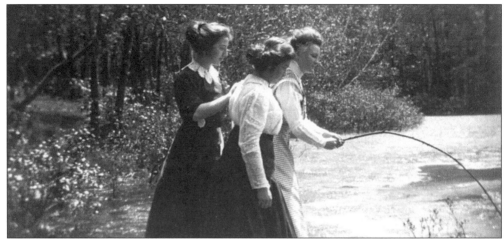

Three CSE students are seen here fishing in the pond behind the present site of Saint Joseph Hall, near Nazareth Park. (CSE Archives.)

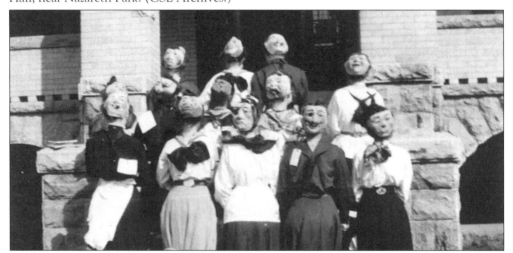

This group of Halloween student-pranksters (above) wore their clothes backwards for two photographs outside Santa Rita Hall. (CSE Archives.)

The Reverend Lalor McLaughlin, or "Father Mac" as he was affectionately called, ministered at the college for more than four decades. In addition to his duties as chaplain, he taught in the Religion Department. Students admired him immensely, as the poem below indicates. (CSE Archives.)

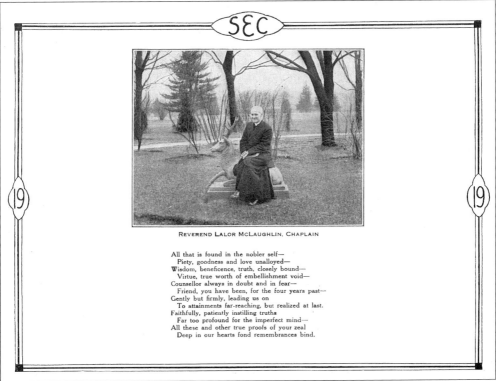

REVEREND LALOR MCLAUGHLIN, CHAPLAIN

All that is found in the nobler self—
 Piety, goodness and love unalloyed—
Wisdom, beneficence, truth, closely bound—
 Virtue, true worth of embellishment void—
Counsellor always in doubt and in fear—
 Friend, you have been, for the four years past—
Gently but firmly, leading us on
 To attainments far-reaching, but realized at last.
Faithfully, patiently instilling truths
 Far too profound for the imperfect mind—
All these and other true proofs of your zeal
 Deep in our hearts fond remembrances bind.

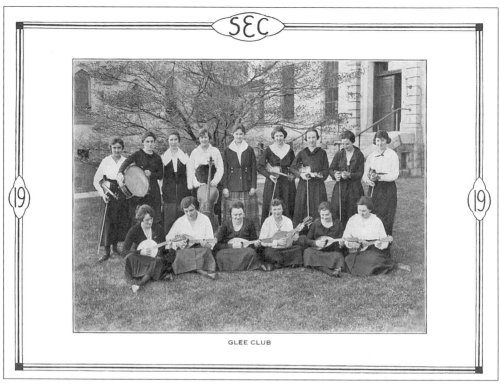

GLEE CLUB

As more students came to the college, the variety of co-curricular activities grew. The musically inclined joined the Glee Club, while the more athletic played basketball and other sports. (CSE Archives.)

THE KEM KLUB

OrganizersIsabel R. Whelan, '19, and Anne V. Reynolds, '19
President ...Margaret Muller, '19
Vice-President ...Margaret Mahon, '20
Treasurer ...Sylvia Concilio, '21

SINCE our advent to S. E. C. in the scholastic year of 1915, the scientists among us, and particularly those interested in chemistry, have yearned for a club. This desire was about to be materialized when the precipitation of the United States into war by the sinking of the *Lusitania* forced our energies into war work and hence all schemes on the subject of a club were held in complete suspension.

At the cessation of hostilities, however, the plan was again attacked vigorously and the smouldering ambition of the students finally kindled in late February of our senior year. The club's organization is mainly due to the altruistic spirit of the History of Chemistry class, whose members wished to extend the beneficial results of their scientific researches—a requisite of their course—to the other lovers of science. This volition was expressed before our moderator, S. M. A., who promised her support in the achievement of the class object.

A meeting of science students was immediately called, and Miss Isabel Whelan, '19, was unanimously elected chairman, and a committee appointed to draw up a constitution. A week later the installation of officers was effected, and the Kem Klub began its career.

The club is open to all students interested in science in general, and its purpose is the diffusion of scientific knowledge in a way to arouse interest. It also gives a general knowledge of chemical phenomena and an insight into the lives of "Who's Who in Science". Two methods are employed in accomplishing the club's aim: first, the reading of papers on research work, and, secondly, discussion of up-to-date scientific questions.

Aside from strictly business procedure, and chiefly to maintain mental equilibrium, the club indulges in bi-annual entertainments. The first of these, given in Santa Maria, took the form of a dinner, followed by a farce entitled "The Misdemeanor of Nancy".

—Anne Reynolds.

Science students established a club for the furthering of both knowledge and diversion. (CSE Archives.)

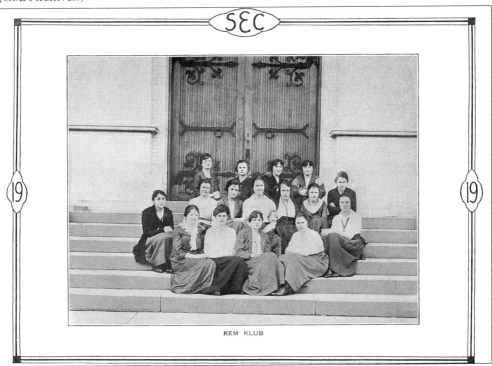

KEM KLUB

Saint Elizabeth

Alumnae Association

College of Saint Elizabeth
New Jersey

War Activities

(Bulletin No. 1)

1918

CSE students and alumnae contributed extensively to the volunteer work made necessary by America's entry into World War I in 1917.

Students and alumnae knitted clothing, made surgical dressings, sent Christmas packages, and sold war stamps and bonds. Alumnae raised funds to furnish and maintain an ambulance used by the Fordham University Ambulance Unit serving in France. (CSE Archives.)

St. Elizabeth Ambulance But there is one activity of the alumnae, indeed of Elizabethans everywhere, in which the heart and spirit of the girls is especially centered, and of which they are deservedly proud. I refer to the *St. Elizabeth Alumnae Ambulance* for the use of the Fordam Unit "over there." This gift, the expression of the zeal and patriotism of Elizabethans, has been presented to Reverend Father Joseph A. Mulry of the Society of Jesus, by the ladies of the ambulance committee. A representative of Father Mulry has come to Convent today to accept formally here, as was done at the Fordham Commencement on Wednesday, the splendid gift of this messenger of mercy and love from St. Elizabeth's to Fordham."

One more evidence of the zeal and patriotism, no less than the spirit of abnegation, which marks the students is their willingness to forego this year, and every year during the war, all medals and prizes, relinquishing them in order to make possible additional help for war needs. The Chapel Commencement also speaks of the wish to conserve the usual expenses of closing: it has its compensations, however, in the nearer presence of our Lord and in the special benediction which will crown this graduation day with a glory that former commencements at St. Elizabeth's have not known."

In addition to the activities enumerated above, the Collegians and Alumnae are planning to form an Elizabethan Library Association, for collecting and sending books to the various Camps.

All articles made for the Red Cross are labeled: American Red Cross. Senior (or Junior) Auxiliary College (or Academy) of St. Elizabeth Convent Station, New Jersey, U. S. A.

30

Three

1920–1929

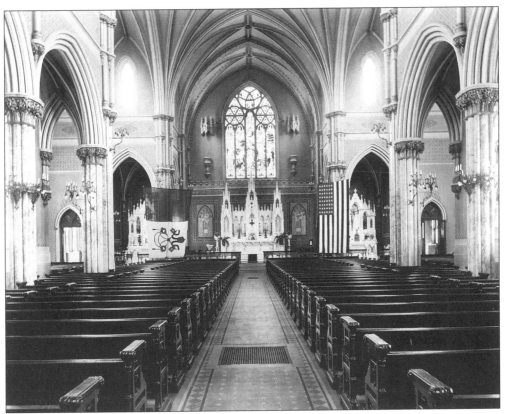

The interior of Holy Family Chapel is the most beautiful and revered site on the campus. (CSE Archives.)

The Alumnae Association of the College of Saint Elizabeth

January 3, 1920.

Dear Alumna:

You are, no doubt, aware that the College Alumnae have formed a distinct and separate association to be known hereafter as the Saint Elizabeth College Alumnae Association, with one main purpose—to further the interests of the College through the Alumnae, and the interests of the Alumnae through their College.

Under the recently elected officers, reorganization is taking place. Quarterly meetings are held at the Waldorf Astoria, New York. College and Academic Alumnae will have the usual social meeting at Convent Station, in November.

At first, a single alumnae association included graduates of both the Academy and the College of Saint Elizabeth. By 1920, the growing number of CSE alumnae necessitated the establishment of a separate alumnae association for graduates of the college. (CSE Archives.)

The pond in the picture above had to be drained to clear the site where O'Connor Hall now stands. Sister Louise Marie Lemee, of the Romance Languages Department, is seen in the foreground of this image. (CSE Archives.)

In the 1920s, the college built two wooden buildings that were connected to one another and served as the inorganic and organic chemistry laboratories. Known on campus as the "White Houses," they were located on the site where Henderson Hall now stands. Three chemistry majors from the Class of 1920 are seen to the right. (Sisters of Charity Archives; CSE Archives.)

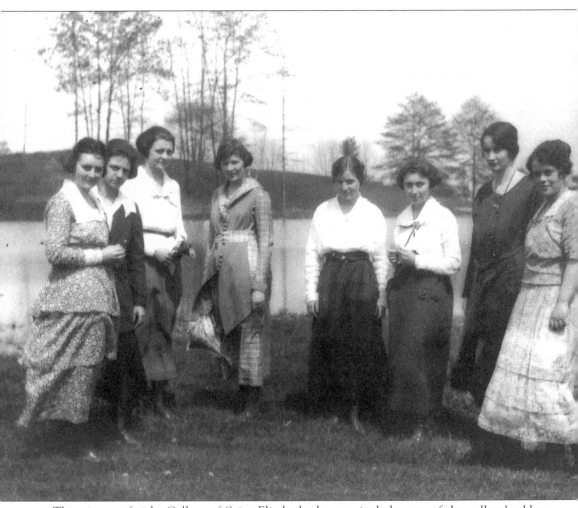

This picture of eight College of Saint Elizabeth alumnae includes one of the college's oldest living graduates, Antonia Higginson (Class of 1922), who stands fifth from the left in the photograph. (CSE Archives.)

Distinguished Nun Educator Is Dead

The funeral of Sister Mary Pauline Kelligar, LL. D., foundress and president of the College of St. Elizabeth, the first Catholic college for women in the United States and the first college for women in New Jersey, was held Aug. 8, at Convent Station, N. J. The Right Rev. John J. O'Connor, D. D., Bishop of Newark, officiated at the Solemn Pontifical Mass of Requiem. The Right Rev. Thomas F. Hickey, D. D., Bishop of Rochester, preached the eulogy. Other clergymen who assisted at the Mass were the Most Rev. Archbishop Seton, the Right Rev. Monsignor F. P. McHugh, archpriest; the Right Rev. Monsignor P. E. Smythe, the Right Rev. Eugene P. Carroll, the Rev. John F. Lyon and the Rev. Matthew J. Farley, deacons of honor; the Rev. John A. Dillon, deacon, and the Rev. William F. Lawlor, sub-deacon. The chaplains to Bishop Hickey were the Right Rev. James F. Mooney and the Right Rev. Thomas J. Kernan, and the master of ceremonies was the Rev. Lalor J. McLaughlin.

Many priests from various parts of the country, several hundred of her own community, Religious of other communities, alumnae and students of the college, relatives and friends, were present to honor the memory of this true Sister of Charity, this beloved and distinguished pioneer in the cause of the higher education of women. For Sister Pauline, in acquiring the right to the latter title, never lost the privilege, in her long and beautiful life, of exemplifying all that the former name implies.

ONCE A PUBLIC SCHOOL TEACHER

Sister Pauline was born at Millstone, New Jersey, in 1847. She was educated at a private academy in New Brunswick and at normal school in Jersey City. She was afterwards a teacher in the public schools until 1868 when she entered the community of the Sisters of Charity at Convent Station. In 1877 she was appointed directress of the Academy of St. Elizabeth. In 1899 she founded the College of St. Elizabeth, of which she continued to be president until 1922. From 1903 to 1906, as Mother Assistant, she was associated in the work of legislating for the community with Mother Mary Xavier Mehegan, its foundress. Fordham University, in 1917, conferred upon Sister Pauline the degree of LL. D., in recognition of her signal achievements in the field of Catholic education. To her may be attributed largely the movement for the higher education of women in religious communities; and to her, in the early days of the College of St. Elizabeth, from all over the country there flocked, for consultation and advice, numbers who regarded her as the valiant leader

in a great cause. Her death, Aug. 5, after a prolonged illness, borne with a patience and gentleness never to be dissociated from her exquisitely refined nature, will inevitably turn the thoughts of many from their present successes to those first early endeavors which she not only encouraged but more frequently inspired.

AT THE FUNERAL SERVICES

The beautiful qualities of her nature and the greatness of her work were eloquently set forth in the sermon of eulogy preached by the Right Rev. Bishop of Rochester.

At the conclusion of the eulogy, the remains of the revered Sister were viewed by the community, then followed in long and solemn procession by clergy, Sisters, relatives, friends, alumnae and students, to the place of burial, Holy Family Cemetery, at a distant part of the college grounds.

Sister Pauline is survived by two nephews, Frank Kelligar and Bertrand Parker, of Newark, Miss Leona Parker, Mrs. James Morse, Mrs. J. Callan, Mrs. Zaremba, all of Newark, and Mrs. Hickey, of Somerville, New Jersey.

Among those present were Dr. James J. Walsh, Stephen H. Horgan, Mrs. William H. McCormack, of Perth Amboy, N. J.; Mrs. A. Doughty, of Detroit, Mich.; Mrs. Bernard Shanley, of Newark; Mrs. Peter Smith, of Brooklyn; Mrs. L. Rehill Smith, Mrs. Mary Shea Cunningham, Mrs. A. Gonzales, of New York; Mrs. Lorretta O'Brien Cosgrove, Mrs. F. G. Richters, Mr. and Mrs. Louis Rossi, Miss Nancy Langan, of Perth Amboy; Mrs. Peter Hauck, East Orange; Mr. and Mrs. John Whelan, of Elizabeth.

Sister Pauline Kelligar's death on August 5, 1922, may be said to have ended the college's initial phase of its existence. Her death received much coverage in both the Catholic and secular press. She had lived long enough, as the *Newark Evening News* stated on the day of her funeral, "to see the college flourish and become an institution of strength and importance." (Sisters of Charity Archives.)

Sister Marie José Byrne, the college's second president, fulfilled the duties of that office for longer than anyone. In 1921, the Saint Elizabeth's College Board of Trustees appointed her dean, and after Sister Mary Pauline's death, Sister Marie José performed the duties of dean and president until being formally appointed to the latter post in 1940. A classics scholar, Sister Marie José's precise style of leadership perfectly suited the needs and temper of this long era in the college's history. (CSE Archives.)

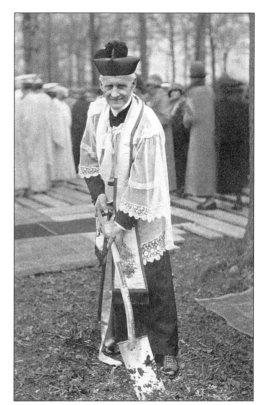

The college's growing student population necessitated the building of a sizable new dormitory. At right, the Reverend Lalor McLaughlin breaks ground for the new building in 1924. Completed in 1926, O'Connor Hall, below, was named for the Most Reverend John J. O'Connor, Bishop of Newark. (Sisters of Charity Archives.)

Inaugural Ceremonies in Honor
of the

Silver Jubilee of the
Founding of the College
of Saint Elizabeth

AND

Twenty-ninth Annual Reunion
of the Associated Alumnae
of Academy and College

Convent Station, New Jersey

Saturday, May 10, 1924

Unveiling of the bronze Mural Tablet in
memory of
Sister Mary Pauline Kelligar, LL.D.
Co-Founder and First President of the College.

(*Gift of an Alumna*)

Breaking of ground for the new College Hall
of Residence followed by
Benediction of the Blessed Sacrament
on the Campus.

"Cor unum et una via."

The ceremony marking the college's Silver Jubilee included a speech given by Miss Mary Ennis, one of the four original graduates. Archbishop Robert Seton, grandson of Saint Elizabeth Ann Seton, gave the Benediction for this ceremony. (CSE Archives.)

Over time, certain campus landmarks, such as the shrubbery-shrouded entranceway (shown here in a c.1920s photograph), have been altered or modernized. The grounds of the College of Saint Elizabeth campus have always maintained an attractive, well-landscaped appearance. (CSE Archives.)

Catholic View of the College Education

By Sister Helen Angela Dorety, Ph. D.

Reprinted from The New York Sun, Aug. 7, 1926.

The increasing number of young people knocking for admittance at all the college doors of the country is plain proof that they and their guardians are thoroughly alive to the superior advantages of the college education. The thoughtful portion of the public are no longer in doubt in this matter. The college has proved itself the greatest intellectual means for advancing the race to the high plane demanded by our growing civilization. Recent glaring demonstrations to the contrary are merely looked upon as exceptions which prove the rule.

It is not the function of the college to teach students how to make a living. College is not designed to make lawyers or physicians or scientists or technicians or business men, or even teachers or clergymen. All these professions have their roots in the college course and are desirable by-products, but every college in Christendom claims as its purpose the production of the cultured and intellectual type of Christian manhood and womanhood. As the best means to this end the college education is the liberal education as opposed to the specialized one, for only a liberal training can develop all the mental powers with which man has been so liberally endowed. Only the liberal education can enrich the mind with the best thought. Man was not made to earn a living, but to use all the means at his disposal to attain his end—the closest intimacy with the God of all Truth.

Sister Helen Angela Dorety, Class of 1904, was the first sister in the United States to receive a Ph.D. (She received it from the University of Chicago.). Her academic field was botany, a subject she taught for many years at the college. Her reflections on the meaning of a college education, written more than 70 years ago, still resonate among discerning minds today. (CSE Archives.)

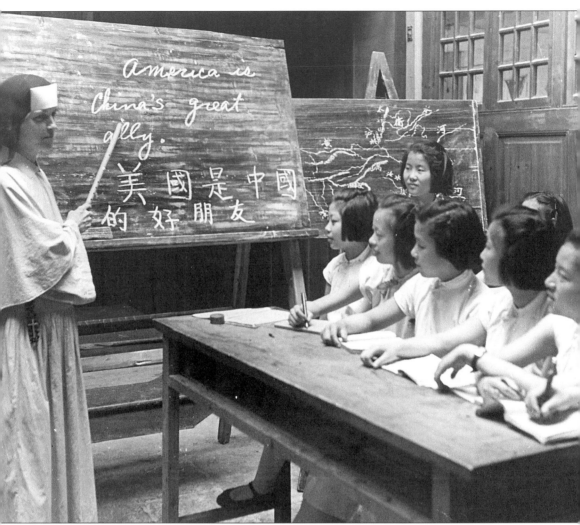

Many CSE alumnae who entered the Sisters of Charity engaged in important ministries well beyond the college campus. Sister Jane Marie Farrell, the only religious in the Class of 1922, was sent to China in 1941, where she taught school until the 1950s, when her mission group was driven from the country. (Sisters of Charity Archives.)

Sister Marie José maintained a watchful eye to insure that the college's reputation and Catholic values were not compromised. By all accounts, her letter to parents sufficed to bring this particular problem to closure, at least in that era. (CSE Archives.)

COLLEGE OF SAINT ELIZABETH
CONVENT STATION
NEW JERSEY

The objectionable features of the prevailing styles of dress and their general adoption by the students made it necessary for the college authorities during the past year to formulate definite regulations regarding dress. These regulations were announced to the students, and were also included among the rules which were made effective at the opening of college last September.

The almost universal disregard of the regulations has resulted in the decision to send this formal notice to the parents of each student, to inform them of the rules and the penalties attached to their infraction. There will then be no misunderstanding, in case it is found necessary to use drastic measures to enforce their observance.

Following are the prescribed regulations:

1. Stockings are not to be rolled.
2. The use of lipstick is prohibited.
3. Skirts are not to be more than 12 to 15 inches from the ground, according to the height of the individual. Skirts are to be pleated or otherwise made to afford ample fulness. One piece dresses do not ordinarily meet this requirement.

4. Sleeveless dresses are not to be worn except at social affairs held in the evening.

These regulations will go into effect immediately after the holidays, and are to be observed by the students not only when attending classes but at all times when under the jurisdiction of the college. Any student who fails to observe them will for a first offense be suspended from classes until her dress satisfies the requirements, for for repeated violations she may even be requested to withdraw from college.

The college authorities solicit the co-operation of parents in this matter, in the hope that the rules may be carried out without the necessity of inflicting these penalties.

The recent public pronouncements of His Holiness and members of the hierarchy on the subject of women's dress do not permit a distinctly Catholic institution to assume an attitude of indifference or to condone fashions and practices thus specifically condemned.

The Sisters of the college take this opportunity to extend to the parents of their students the Season's Greetings and best wishes for Christmas and the New Year.

Sister Marie José
Dean

December 23, 1926.

COLLEGE OF SAINT ELIZABETH
CONVENT STATION
NEW JERSEY

DEC 24
6-PM
1926

Mr. Patrick J. Cooney,

167 Fairview Ave.,

Jersey City, N. J.

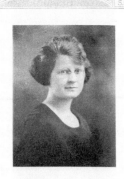

TERESA DEMJANOVICH

Bayonne, New Jersey

Chairman Class Song Committee, 3
Chairman Near East Mission Unit, 4
Vice-President Class, 4
Art Editor of "Elizabethan", 4
Class Poet, 4
Track Team, 1, 2, 3

*"Character is higher than intellect.
A great soul will be strong to live,
as well as to think."*

Teresa is a girl her classmates have felt proud to admire and respect. She has always given her best—and herself on all occasions. That may explain partly "Treat's" superior ability. Always, whether it was a class poem, a poster, or a decorative scheme for an entertainment, Teresa centered the full force of her remarkable intellect and creative powers to execute the work her classmates had asked her to do.

When we unanimously elected this versatile girl Art Editor of the "Elizabethan", we knew we were choosing natural ability and conscientious application. And her work has borne the notes of a genius. It has been characterized by depth of thought, mature insight, and poetic inspiration. Her poem, "A Mother's Heart," which appeared in "Poets of the Future", reveals Teresa, the poet, and Teresa, the woman. A poet is often separated from his character, for the two are not always congenial. But with our Teresa, it is different. That intensity of feeling and that strength of thought which we have found in her "poetical flights," as she jokingly terms her poesy, becomes in her fellowship with us deep sympathy, sincere thoughtfulness and fine impulses. Yes, Teresa, the classmate, is as high-minded as her poetry is lofty. In principle she climbs the heights to which her inspiration soars, and here the power of her soul unites with the strength of her character.

30

1923

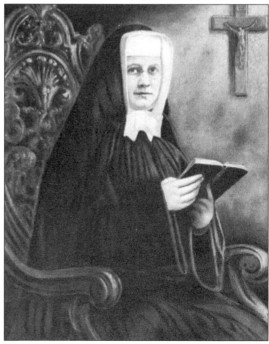

Sister Miriam Teresa Demjanovich, Class of 1923, is a candidate for canonization. She has the title Servant of God. Sister Miriam Teresa entered the Sisters of Charity in 1925. She wrote a series of spiritual conferences, which were collected in a volume titled *Greater Perfection*. Sister Miriam Teresa died in 1927. (CSE Archives; Sisters of Charity Archives.)

Four
1930–1939

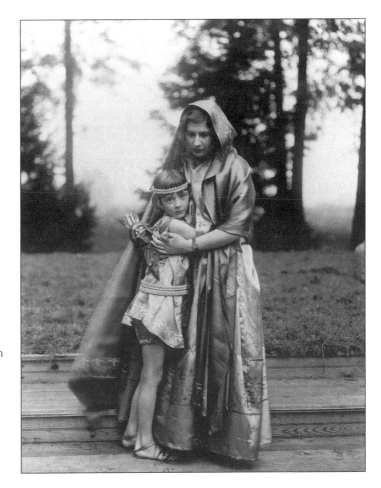

In 1930, the college staged its first production of a Greek play, the *Trojan Women of Euripides*, in honor of Virgil's bimillennium. The performance was held outside, near Santa Maria Hall. (CSE Archives.)

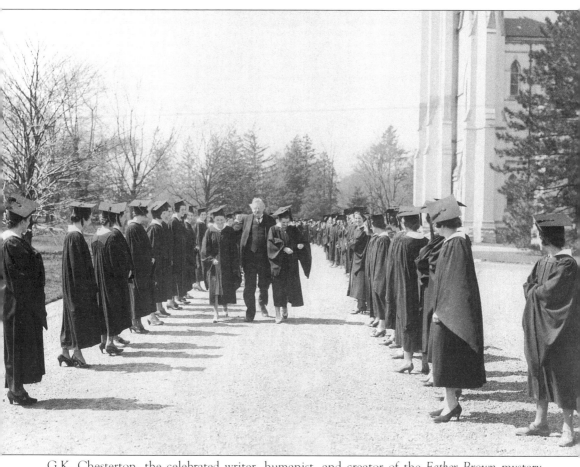

G.K. Chesterton, the celebrated writer, humanist, and creator of the *Father Brown* mystery stories, visited the campus in 1932. An elaborate welcoming ceremony commemorated his arrival. (Sandrian/CSE Archives.)

The college's first Nevin House, the home-management practice house used by the Home Economics Department, was named for Sister Mary Catharine Nevin, an assistant to Mother Xavier. Nevin House was located near the present site of St. Thomas More Church but was demolished in the early 1970s. The Botany House, seen below, provided an excellent laboratory facility at a time when this subject was very popular with CSE students. At present, the structure serves as the college's greenhouse. (CSE Archives.)

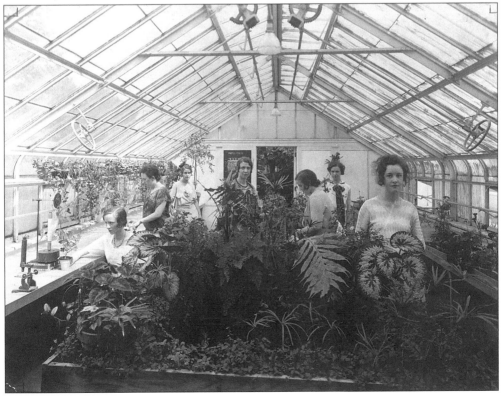

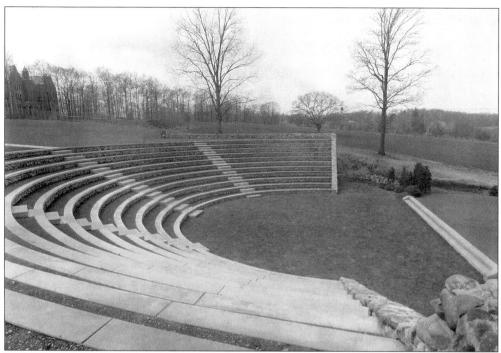

In 1932, the college's Greek Theater was completed. Sister Marie Victoire Corr, a Latin professor, supervised the construction of this campus landmark. Situated on the hillside adjacent to Santa Maria Hall, the structure is an authentic reproduction of the theater of Dionysius near the Acropolis in Athens. Euripides's *Electra* was the first performance held in the Greek Theater. The occasion marked the start of a college tradition of staging a Greek play every four years. (Sandrian/CSE Archives.)

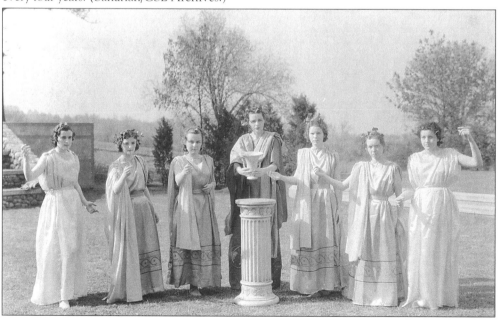

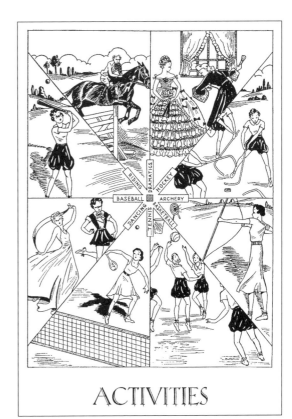

ACTIVITIES

Equestrianism has long been one of the most popular athletic activities among CSE students, but this is only one of the many sports that have been available at the college, as indicated on this page (at right) from the *1936 Elizabethan Yearbook*. (CSE Archives.)

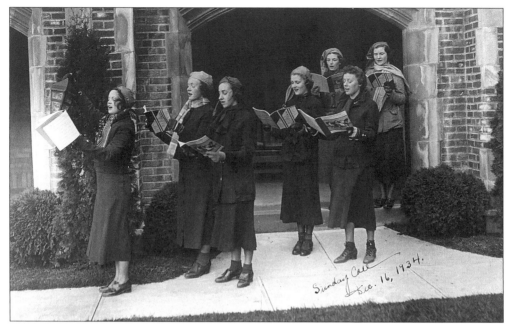

Sunday Call
Dec. 16, 1934.

Above, student Christmas carolers provided some seasonal cheer to the residents of Saint Anne's Villa, the nearby home for the aged and infirmed Sisters of Charity, in December 1934. Below, a student-officer of the 1931 Social Action Committee reports on the group's Christmas activities. (CSE Archives.)

Report on Christmas Work

Provisions for the poor of Whippany for Christmas 1931 were in the charge of the Social Action Committee. This committee, headed by Ella Sullivan, included also one representative from each class, Helen Reed, Marcie Mulcan, Helen La Porte, and Jane Murray.

The Student Body was asked to bring back old clothes to supply the families assigned to us by Father Clifford of Whippany. These clothes were collected in room 134 O'Connor Hall where they were assorted and wrapped for each family by Sr. Esther Marie.

Along with the clothing, each member of the committee collected one dollar apiece from the girls in her class. Also the college and departmental clubs contributed to the cause.

The money was used to supply the ten families each with a basket of food. A poor family in Morristown was also included. The ordering of these baskets was taken care of by Mr. Wagner, the college chef. These baskets were delivered with the clothing on Christmas Eve by means of the college truck.

The remaining sum of money is being used for the benefit of the poor children of Whippany who may need clothes throughout the year.

Report written by Miss Ella Sullivan
Respectfully submitted,

48

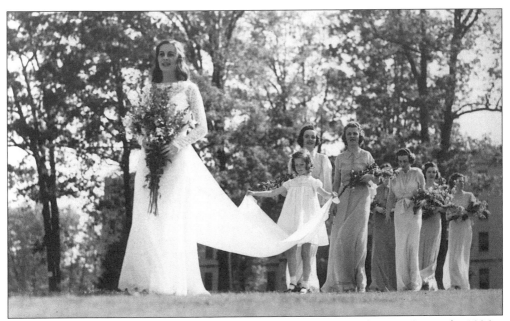

The campus' May Day ceremonies had deep spiritual significance. The May Queen for 1936 is seen above being crowned. As seen below, a Maypole ceremony took place in 1937 in the Greek Theater. (CSE Archives.)

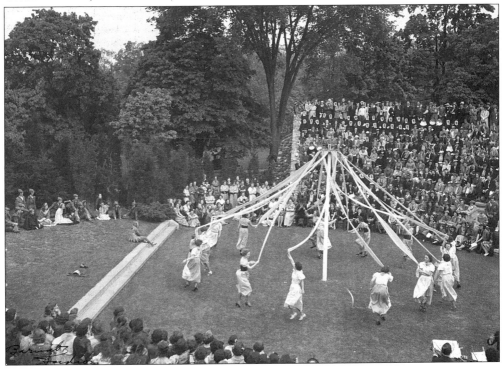

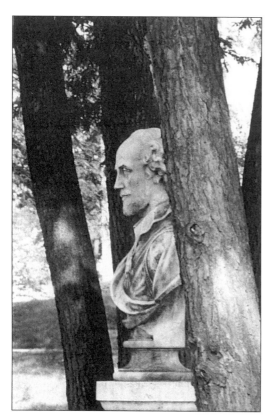

One of the most beautiful spots on the campus, the Shakespeare Garden, was the brainchild of Sister Helen Angela Dorety. Under her direction, each of the garden's plots represented one of the Bard's plays or poems, with small white markers indicating the source. A bust of Shakespeare crowns the garden. The ingenious project, completed in 1931, was greatly assisted by Mr. Charles Totty, a prominent horticulturist and father of Helen Totty, Class of 1919. (CSE Archives.)

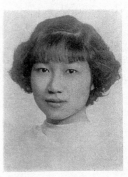

LENORE YUNG SU LOE, A.B.

Peking, China

. . . Coming towards us across the room, we see a young girl, almost childlike in appearance, yet with the maturity and control of the adult. She amazes us with her understanding of Philosophy and her cleverness at Math. A happy faculty of adapting herself to a strange people and a strange culture. High ideals direct her powers and a strong determination upholds her scholarship to us. Lenore bears some of the mellowness of a long civilization; a charm and an inner delicacy of an old culture . . .

One of the college's first international students graduated with the Class of 1939. Lenore Yung Su Loe, a Chinese national from Peking, majored in chemistry. Unable to return home because of the Sino-Japanese conflict, she remained in America. She earned a master's degree from Fordham University, married, and has lived a happy and successful life. She remains ever grateful to the college. "Spiritually, educationally, it has made me what I am now." (CSE Archives; Harvey Photographer/CSE Office of Communications and Marketing.)

MESSAGE SENT TO HIS HOLINESS, POPE PIUS X11

His Holiness, Pope Pius X11
Vatican City
Rome

Your Holiness,
 The Alumnae Association of the College
of Saint Elizabeth, Convent, New Jersey, the first
Catholic College for women in the United States,
wishes you the blessings of God.

 Katharine McLaughlin
 President

The Alumnae Association sent a message of congratulations in March 1939 to Pope Pius XII, upon his election to the Papacy. Through Monsignor Giovanni Battista Montini (later Pope Paul VI), the Holy Father sent a telegram reply of appreciation. (CSE Archives.)

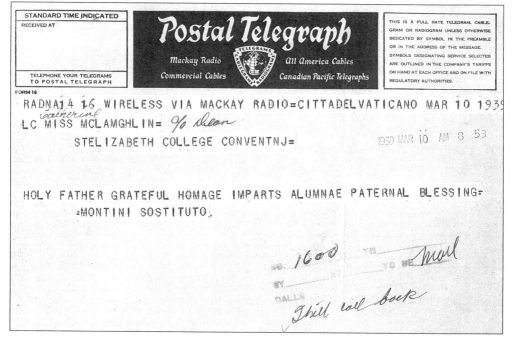

Five

1940–1949

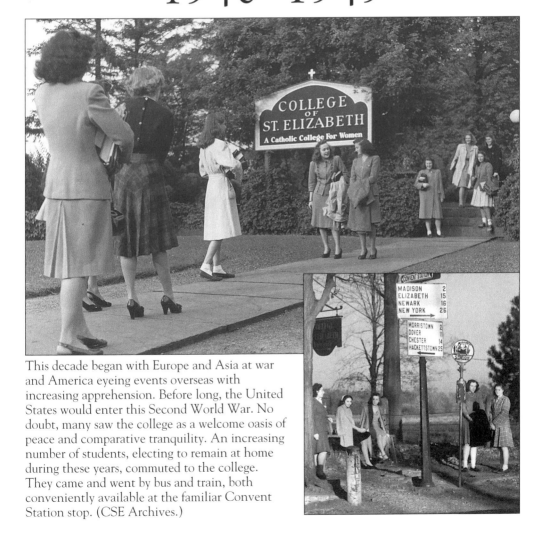

This decade began with Europe and Asia at war and America eyeing events overseas with increasing apprehension. Before long, the United States would enter this Second World War. No doubt, many saw the college as a welcome oasis of peace and comparative tranquility. An increasing number of students, electing to remain at home during these years, commuted to the college. They came and went by bus and train, both conveniently available at the familiar Convent Station stop. (CSE Archives.)

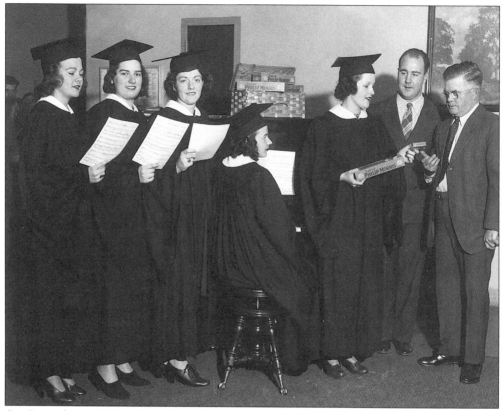

On December 17, 1941—just ten days after the attack on Pearl Harbor—members of the college's Glee Club (seen above) entertained at a nearby veterans' hospital. As seen below, the Greek Theater provided the site for the 1943 War Rally, in which visiting servicemen participated. (CSE Archives.)

Nurse's Aides Graduate At Convent

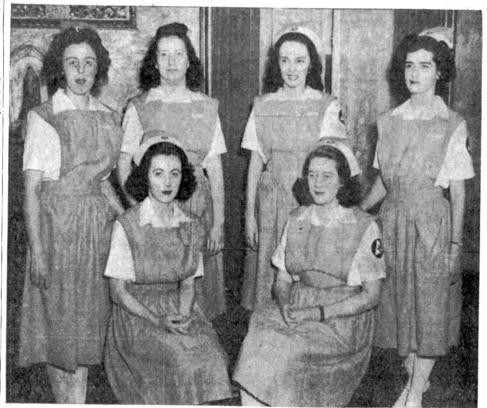

Standing left to right: **Marie Thebault**, Madison; **Catherine Moran**, Jersey City; **Margaret Fenton**, Newark; **Barbara Kane**, West Hartford, Conn. | Seated: **Helen Murphy**, Syracuse, N. Y.; **Eleanor Maloney**, Jackson Heights, L. I. Three other gradates are not in the picture.

CSE students and alumnae found ways to contribute to the effort. Six college students (as well as three others not pictured above) completed a nurses' aide training program with the American Red Cross in 1944. The students did their practice work at All Souls Hospital, Morristown, and they received their certificates at a campus ceremony. Captain Lucille M. Donnelly (Class of 1938), pictured at right, is on duty at the first Women's Army Corps training center at Fort Des Moines, Iowa. (CSE Archives.)

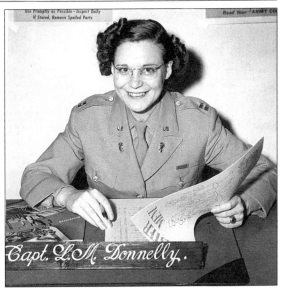

Capt. L. M. Donnelly.

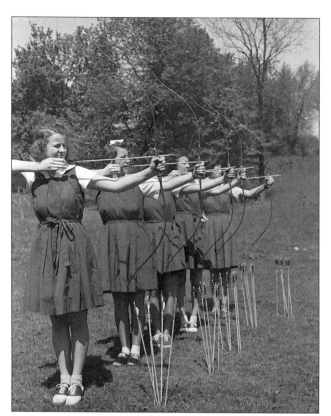

Clad in the physical education uniforms of the time, students in an archery class take aim at their targets. Students, pictured below in 1942, performed the *Trojan Women* in the Greek Theater. (CSE Archives.)

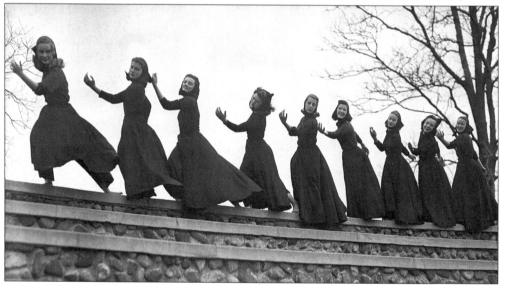

Every campus has its best-remembered landmarks. At CSE, these landmarks include the Seton Dining Hall (above) and the staircases of Xavier Hall (below). For some 70 years, resident students ate their meals in Seton Dining Hall. In the picture below taken in 1946, students ascend to Xavier's fourth floor to participate in the Freshman Investiture Ceremony. (CSE Archives.)

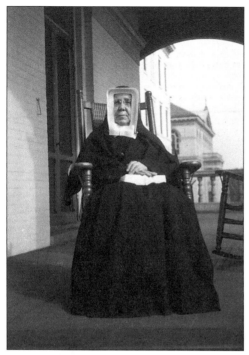

In the 1940s, science courses remained a predominantly male province at some colleges. The popularity of CSE's science curriculum in that era can be seen by this photograph of chemistry students then enrolled at the college. All of these students were taught by one of the college's most eminent faculty members, Sister Augustina Brobston (left). (CSE Archives.)

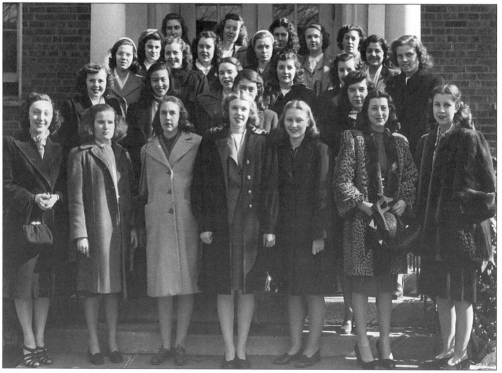

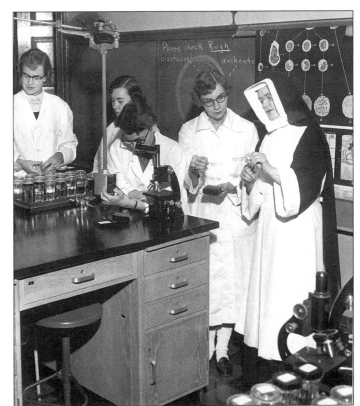

Students, pictured below in a chemistry laboratory class, concentrate on their experiments. Sister Anna Catherine Lawlor (right), of the Biology Department, helps students master this challenging subject. (CSE Archives; Sisters of Charity Archives.)

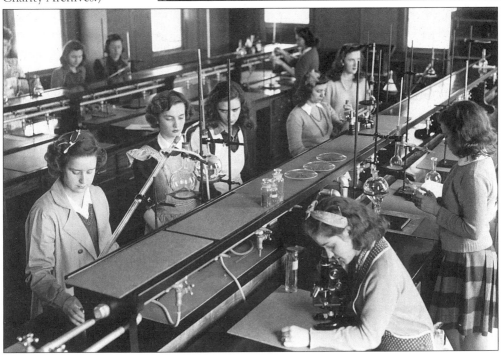

THE MISSION UNIT

The Mother Xavier Mission Unit, holding the regional N.F.C.C.S. commission on Mission Activity, continued this year—through its powerful medium, the trinity of prayer, work and sacrifice—to better the understanding of mission problems and increase the material contributions to far-off mission fields. These mission problems are discussed by study groups; and for outstanding achievement in the field the jeweled Paladin is awarded. This year the group has placed special emphasis on the theme of the C.S.M.C. convention, the Christianization of America.

The dire needs of foreign missions, particularly those of war-ridden China, have given added impetus to the annual Mission Day, China Day Sale, the Penny Drive, weekly cake sales, and the Ice Ball.

The officers, President, Mary Lou Clarken; Vice-President, Bobbie Burns; Secretaries, Mary Eibell and Mary Birkenhauer; and Treasurer, Claire McDonough, give a vote of thanks to Sister Mary Cecilia, club moderator, and the executive board, whose unstinting help and advice have done much to make this such a successful year.

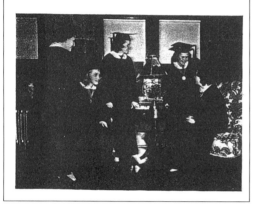

The Mother Xavier Mission Unit exerted a powerful influence on the college's student body by making it aware of the need for the cooperation of the lay person in the work of the missionary. The photographs on this page, including the one of the medal worn by students who served in the Mission Unit, are from the 1949 *Elizabethan Yearbook*. (CSE Archives.)

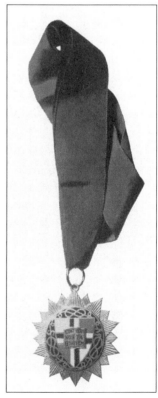

The CSE Home Economics curriculum included such courses as tailoring, textiles, nutrition and dietetics, institutional buying, and merchandising methods. Home economics majors also published their own campus newspaper, the *Loretto* (named after Sister Loretto Basil Duff). This paper publicized activities concerning this popular program of study. In 1991, the home economics program was revamped, and majors in the renamed Foods and Nutrition Department earn bachelor of science degrees upon completion of their studies. (CSE Archives.)

Remember May Is Mary's Month

The Loretto

Support 'Knave of Hearts' May 15-16

Vol. I No. 3 Department of Home Economics, College of St. Elizabeth, Convent, N. J. May 10, 1948

Receives Award

Patricia Kelley

Pat Kelley, Others To Receive Award

Patricia Kelley, '48, a member of the Home Economics group is to receive the Paladin Jewel for outstanding mission work on campus, when Monsignor McLaughlin makes the presentations in Holy Family Chapel at Benediction, Tuesday, May 18 at 7 P.M.

Other Mission Unit members to receive the Paladin Leader award are Virginia Sweeney, Pat Tobin, and Joan Crowley. These students have held membership in the Unit study clubs for three years.

Many members of the Home Economics Department are active members in the Mission Unit, participating in study clubs, working on food sales, and other programs sponsored by the Unit.

The Paladin Companion with merit, awarded for two years' work on study clubs, will be given to Rita Kramer, Peggy Nugent, Patricia McGovern, and Phyllis Serpico, also seniors.

The Paladin Companion for one year's work will be received by Anne McLaughlin, Betty Ann Walsh, Polly Walsh, all of '48. Barbara Burns who is a junior and Pat O'Donnell, a sophomore, will also receive the Companion.

Thanks to You!

This issue of the "Loretto" was made possible by the kindness of the following freshmen who donated their time most generously in the cafeteria on the day of the food sale: Joan Lavelle, Frances McAward, Rita Pandiscio, Katherine Math, Corine Yell, Rose Mary Ross, Marcella Sheedy, Mary Gabrielle, Peg Sweeney, Eleanor Cardinal, Jane Dowd, Paula Tierney, Beth Tietjen, Claire Flood, Claire Howard, Charlanne James, Alene Rager, Marie Felleny, Ann Long, Joan Parkinson, Emily Brown, Joan Carr, Mary Nolan, and Pat Lord.

Seniors Are Inducted Into Organization

The senior members of the Home Economics Club were formally inducted as members of the American Home Economics Association, Saturday, May 1. The ceremony started at 2:00 and was held in the reception room of O'Connor Hall.

Social to Follow

Following the ceremony, the Club spent an enjoyable afternoon with the mothers of all its members at a Mother-and-Daughter Social on the lawn of O'Connor Hall. Tables for bridge were set up for those who chose to play.

Guests were welcomed by Adelaide M. Belliotti, general chairman. Assisting the chairman in preparation for the affair were Cecilia Harris, chairman of the Induction ceremony; and Anne M. Cronin, who was in charge of refreshments.

Thirty-one New Members

Miss Elizabeth Scott, of the

(Continued on Page Three)

Plans Are Announced for "Musical Revue Of Fashion" to Be Shown in Xavier Hall

Freshmen, Juniors to Model Their Clothes At Fashion Show on Wednesday, May 26

A Spring fashion show, under the direction of Mrs. Skelton, moderator of the Home Economics Club, will be given in Xavier Auditorium on Wednesday evening, May 26. Alice Goerner is acting as general chairman.

Ensembles will be modeled by students in the show, which is entitled "Musical Revue of Fashion."

President-Elect

Mary Jane O'Brien

Officers Elected At Club Meeting

Anne McLaughlin presided at the last meeting of the Home Economics Club which was held in O'Connor Lounge, Thursday, April 8. The most important business at this meeting was the election of club officers for the college year 1948-1949.

Though the votes were cast, a quorum of club members was not present, and the elections were declared invalid and held again on April 13 in the auditorium. At that time Mary Jane O'Brien, '49 was elected president; Adelaide Belliotti, '49, vice-president; Ann Smith, '50, treasurer; Pat Knaus, '51, secretary.

After some discussion on the club's Class A production for next year, the members voted for a fashion show and bridge.

The Singer Sewing Center in Morristown demonstrated the steps in producing a plastic dress form. Catherine Math, a freshman Home Ecoer, was the model.

(Continued on Page Three)

The freshmen will exhibit the cotton dresses that they made in first semester and the juniors will wear the two garments which they designed and executed this year in their tailoring course. Oppenheim Collins of Morristown is donating accessories.

Miss Goerner asks that all who wish to help in the planning and painting of scenery, sign the lists on the Home Economics bulletin board or in the clothing laboratory.

The performance is scheduled to start at 7:30, Wednesday evening. No admission fee is to be charged. All students are asked to come and they may extend this invitation to their parents.

Fashion Preview

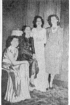

Left to right—Barbara Baxter, Mary Markey, Sylvia Hurzeler, and Peggy Hughes.

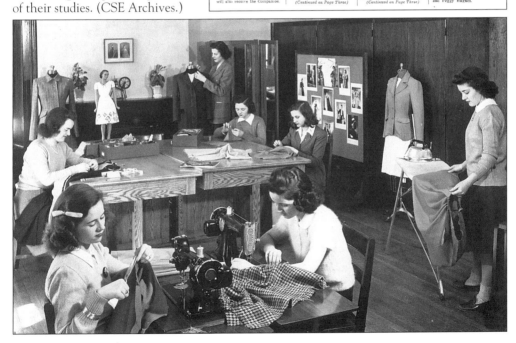

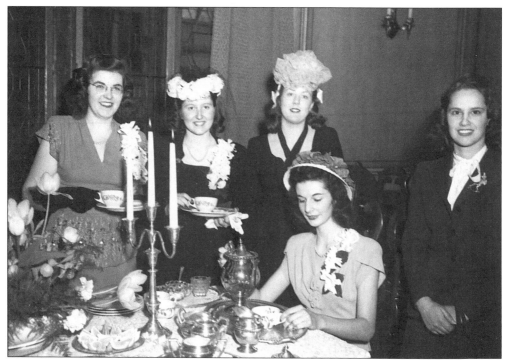

Tea socials and tea dance events provided elegant and sophisticated milieus for conversation and romance. College students (above) mingle with United Nations delegates and representatives at a tea held on March 23, 1947. Members of the junior class (below) enjoy a Saturday afternoon in the "Big Apple." (CSE Archives.)

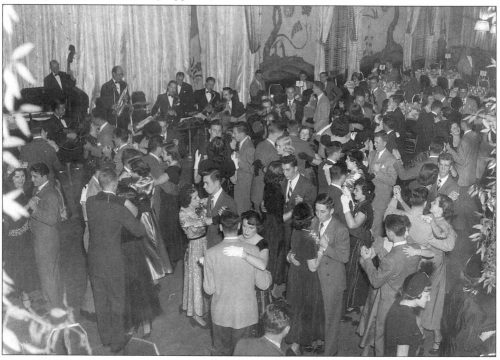

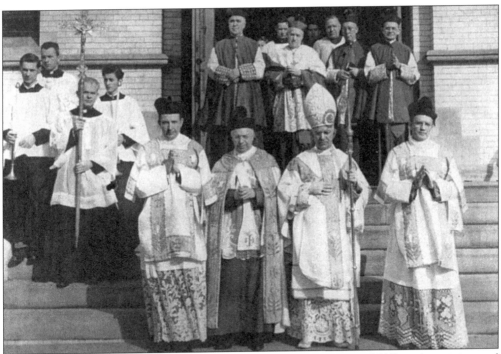

The college's Golden Jubilee Year capped a half-century of success in fulfilling the mission and ideals of the institution's founders. A Solemn Pontifical Mass (above) in Holy Family Chapel inaugurates the Golden Jubilee Year on January 22, 1949. The Most Reverend Thomas A. Boland, Bishop of Paterson, celebrated the Mass. The Class of 1949 (below) attends the Baccalaureate Mass in Holy Family Chapel. (CSE Archives.)

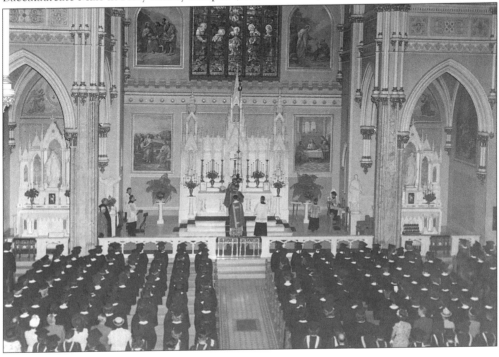

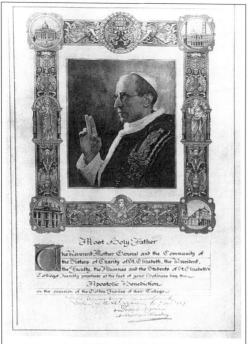

APOSTOLIC BENEDICTION

The College has received two expressions of our Holy Father's benevolence. At the opening of the Jubilee Year, His Holiness cabled congratulations to the College, Alumnae and Students. Then at the close of the Jubilee Year, the Most Reverend Thomas Boland, Bishop of Paterson, returning from his ad limina visit to Rome, brought with him and presented to Sister Marie José this oil painting, which is a permanent expression of the Pope's interest in the College of St. Elizabeth. When the alumnae return to Convent on Alumnae Day, they may see this beautiful painting which has been hung outside Seton Parlor in the Administration Building.

The college's Golden Jubilee attracted attention and praise in Rome and in Washington. At the close of the Jubilee Year, the Most Reverend Thomas Boland, Bishop of Paterson, returned from his *ad limina* visit to the Vatican. He brought with him and presented to Sister Marie José a painting (left), which serves as a permanent expression of the Holy Father's interest in the college. (CSE Archives.)

THE WHITE HOUSE
WASHINGTON

March 30, 1949

Dear Reverend Sister Marie José:

I have learned with much interest that the College of Saint Elizabeth will celebrate this year the Golden Jubilee of its founding.

The college's record of achievement is written into the lives of the thousands of women whose characters were formed in the spiritual atmosphere of their Alma Mater.

I trust that the college will continue its good work and that the sphere of its influence will widen as it goes forward to a full century of usefulness.

Very sincerely yours,

Harry Truman

Reverend Sister Marie José,
President,
College of Saint Elizabeth,
Convent Station, New Jersey.

Six
1950–1959

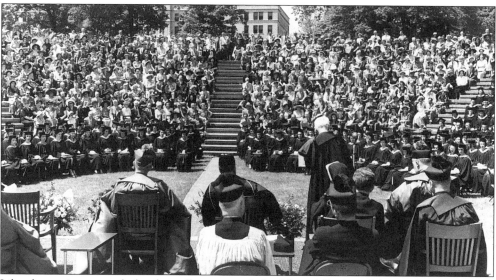

Like the nation as a whole, the college entered the fifties full of confidence about its future. Pictured above is the Commencement Ceremony of 1950 with the Reverend Lalor McLaughlin standing at the podium. After ministering to several generations of college students, Father "Mac" died in November 1958. A strong sense of tradition prevailed on campus in the 1950s. One memorable custom held that the members of each class adopt and wear designated colors (red, blue, green, or purple) and a class beanie (below) at special campus events. (Sisters of Charity Archives; CSE Archives.)

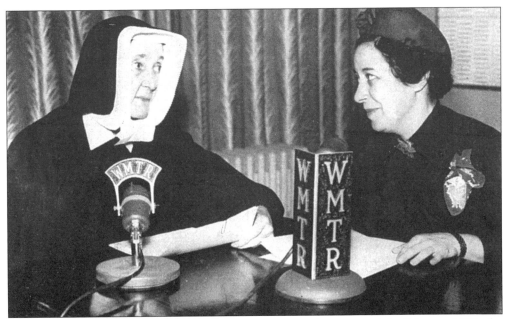

Sister Marie José's forward-looking leadership never waned or wavered. In February 1951, she was interviewed by Agnes Butera, Class of 1936, as part of a series of radio interviews with New Jersey's college leaders, conducted by station WMTR in Morristown. Sister Marie José died on November 11, 1951. When members of the Class of 1917 (below) returned to campus for reunions, they had a chance to be reacquainted with a distinguished classmate, Sister Mary Catherine O'Connor, who taught in the English Department for many years. (CSE Archives.)

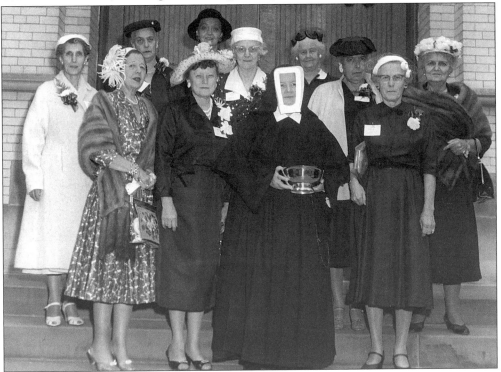

Sister Hildegarde Marie Mahoney became the college's third president in September 1952, after teaching Latin and religion at the college. For the next 19 years, CSE benefited immensely from her strong, steadfast leadership. (Sisters of Charity Archives.)

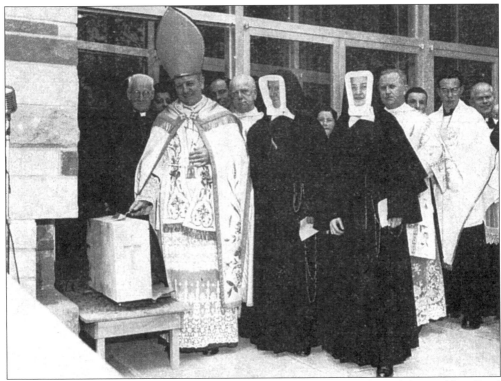

Thanks in part to the efforts of alumnae who staffed the college's Golden Jubilee Building Fund Committee, a new activities building, Saint Joseph Hall, graced the campus in 1954. The laying of the cornerstone for this structure is pictured above. Presiding over this ceremony are, from left to right, Bishop James A. McNulty, Mother Ellen Marie McCauley, and Sister Hildegarde Marie Mahoney. (CSE Archives.)

The lounge area (below) of Saint Joseph Hall provides a meeting spot and rest haven for guests and members of the campus community. Saint Joseph Hall remained in impeccable order for many years, thanks to the labors of its maintenance man, Mr. Joe Barnacle (right). (CSE Archives.)

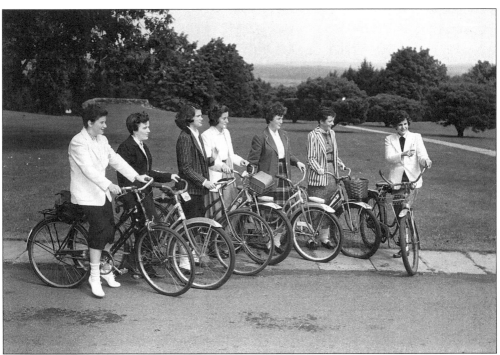

The annual Mother-Daughter Weekend, in which senior-year students and their moms participate in college-sponsored activities, was as popular in the 1950s as it is today. In the picture below, Sister Cathleen Maloney, Class of 1942, stands with her mother, Adele Powers Maloney, Class of 1914 (back row, third from right), and her sister Therese Maloney, Class of 1951 (back row, third from left), a member of the college's board of trustees. (CSE Archives.)

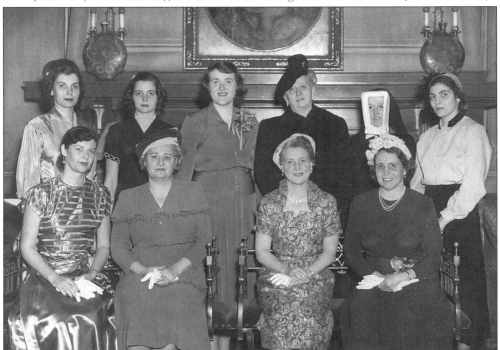

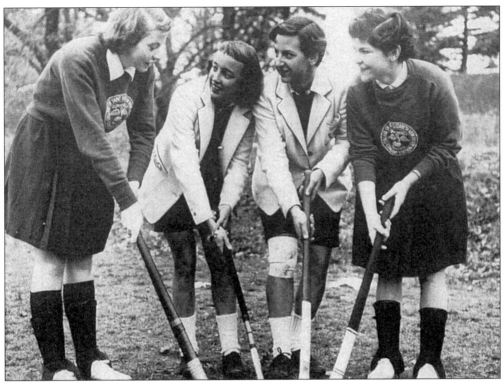

In the 1950s, class competition became available in nearly every sports activity. CSE and rival Centenary College field hockey players prepare for a match (above). Students receive instruction in fencing (below) in Saint Joseph Hall's studio. (CSE Archives.)

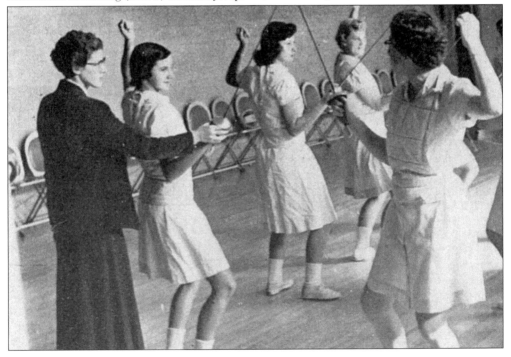

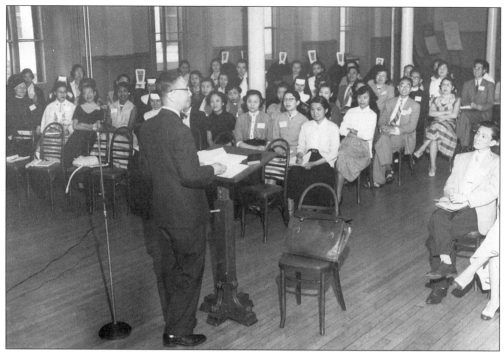

During this decade of international strife, CSE sought to foster intercultural cooperation and understanding. From June 8 to June 13, 1953, the college hosted the Catholic Far Eastern Students Seminar. Dr. John Wu, of Seton Hall, is pictured above delivering a lecture. A Japanese woman (below) entertains an attentive audience. (CSE Archives.)

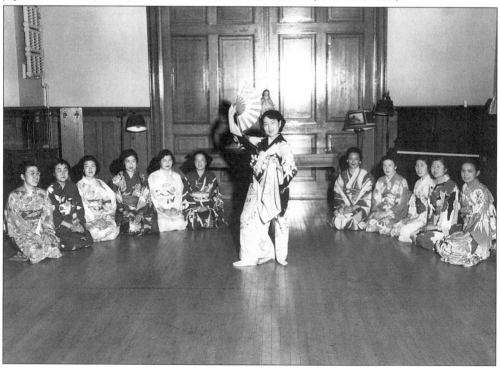

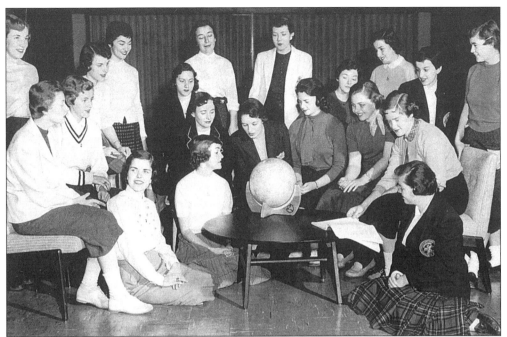

Amidst the Cold War tensions of the 1950s, CSE's International Relations Club, then one of the oldest organizations on campus, promoted interest in U.S. foreign policy and global affairs in general. The club's ultimate purpose was to advance the college "in conformity with the mind of the Church, the Peace of Christ in the Kingdom of Christ." Above, the club convenes in 1956. (CSE Archives.)

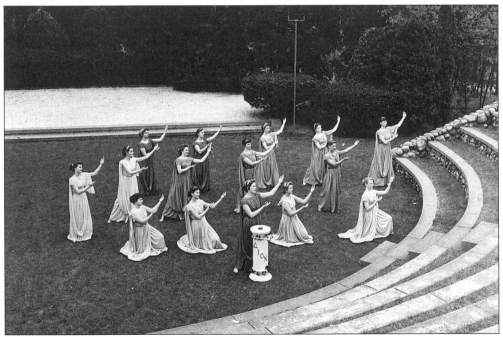

Electra, written by Euripides, was performed May 14–15, 1955, in the Greek Theater. (CSE Archives.)

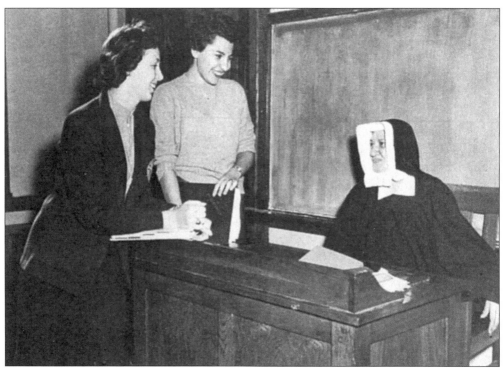

Sister Francis Augustine Richey, a long-time and renowned member of the Philosophy Department, contributed substantially to maintaining the college's tradition of academic excellence. (CSE Archives.)

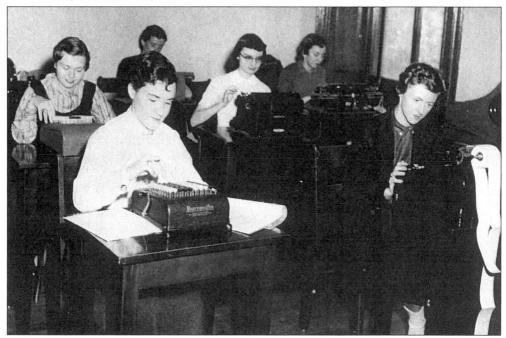

Then and now, College of Saint Elizabeth students are encouraged to develop practical skills. Business students are seen above operating 1950s-era calculators. (CSE Archives.)

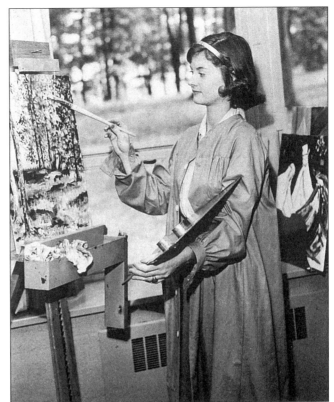

As is the case today, CSE in the 1950s offered a strong humanities curriculum. An art student, seen at right, expresses herself on canvas. Sister Constance Marie Wallace (below), a long-time French professor at the college, is pictured teaching a class. (CSE Archives; Sisters of Charity Archives.)

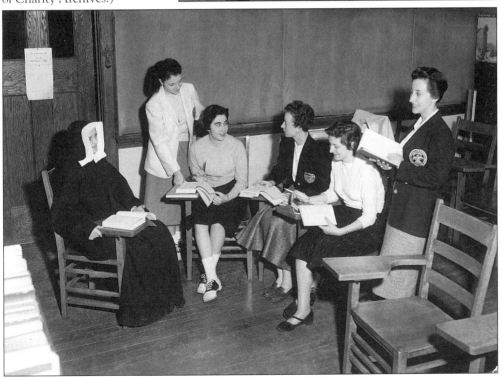

Members of the campus group Sodality endeavored to make liturgy the key to a ruled, daily spiritual life and the spark of a program for apostolic work. (CSE Archives.)

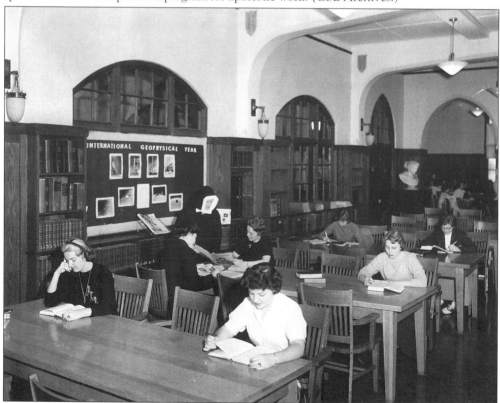

Sister Francis Charles (Sister Marie Rousek) assists student patrons of the library, then housed in Santa Maria Hall. Sister Marie later served as director of Mahoney Library until her death in November 1990. (Sisters of Charity Archives.)

Seven

1960–1969

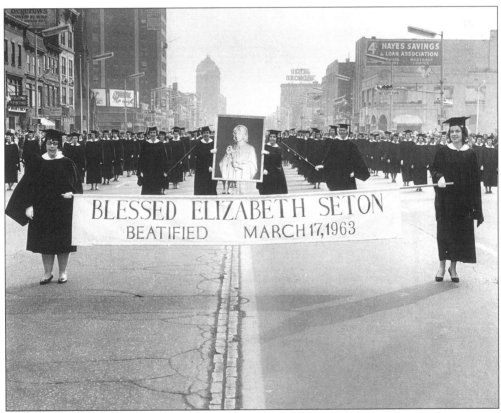

CSE students regularly marched in St. Patrick's Day parades held in New York City and Newark. The students who participated in this 1963 parade used the opportunity to commemorate a truly exceptional event, the Beatification of Mother Elizabeth Ann Seton. (CSE Archives.)

A new science building, Henderson Hall, was completed in the fall of 1962 and was the first of three major additions to the college's physical plant during the 1960s. The building was named for the Henderson family (below), who have been among the college's most generous benefactors. (CSE Archives.)

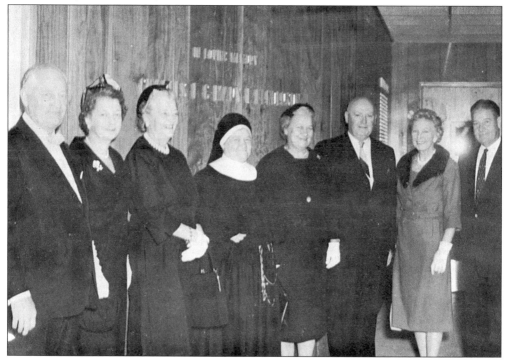

The annual summertime Bazaar Day combined fun with fund-raising. Representatives of each mission of the Sisters of Charity, including the College of Saint Elizabeth, set up booths and sold small handicraft articles to crowds that sometimes numbered in the hundreds. Revenues went to support Sisters of Charity-run programs and initiatives. Staffing the booth below, from left to right, are the following: (bottom) Sister Dorothy Clare Cannon, Sister Ellen Mary Desmond, and Sister Marguerite Francis Goodwin; (top) Sister Elizabeth Marie Houlihan. Bazaar Day had its lighter side, too. Sister Anita Richard Heilenday (right), a long-time chairperson of the Home Economics (later Foods and Nutrition) Department, ruled the roadway.

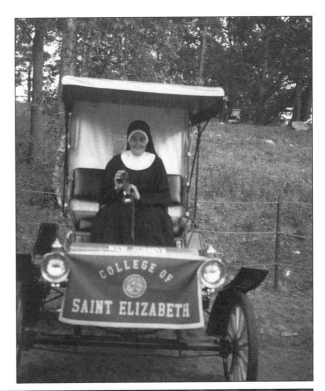

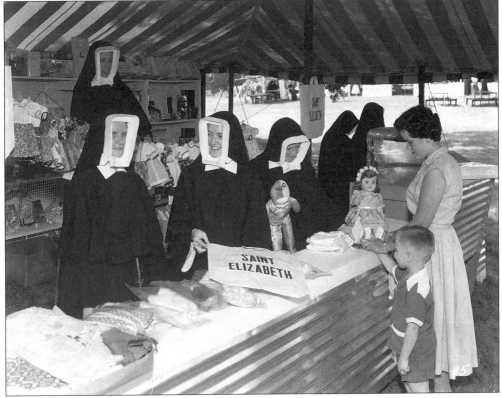

The Junior Ring Ceremony is a long-time annual tradition at the college. In the ceremony, members of the junior class have their class rings blessed during a Mass at Holy Family Chapel. Sister Hildegarde Marie (left) congratulates Mary Ellen Grant, Class of 1961, the chairperson of her class's Ring Ceremony committee. (CSE Archives.)

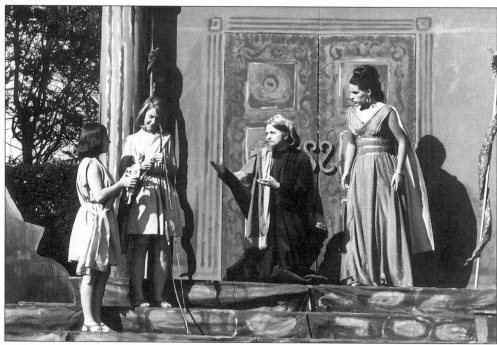

Medea of Euripides was performed from May 14 to May 16, 1965, in the Greek Theater. (CSE Archives.)

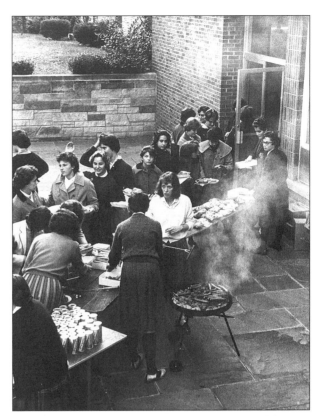

Autumn outdoor barbecues (right) sent students flocking to the downstairs patio area of Saint Joseph Hall. An annual aqua show (below), held in the Saint Joseph Hall pool, featured graceful, athletic synchronized swimming performances. (CSE Archives.)

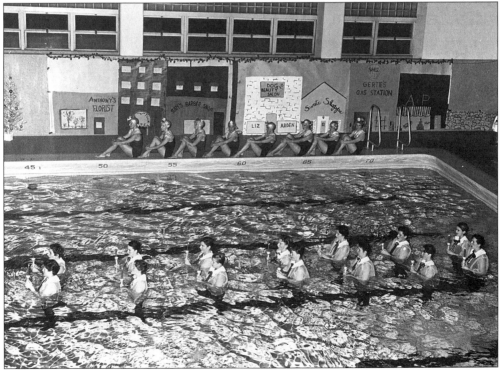

In 1966, the college opened a new dormitory, Founders Hall. Built to accommodate 166 resident students, Founders Hall also includes the college's health center. (CSE Archives.)

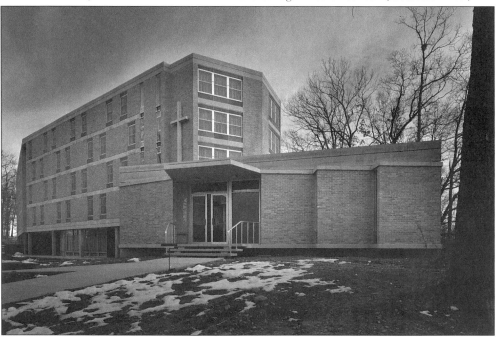

Henderson Hall's attractive appearance was further enhanced through the creative labors of the Art Department's Sister Marie Imelda Hagan. She created a four-foot sculpture of St. Vincent de Paul, which is located on the second floor of Henderson Hall. (CSE Archives.)

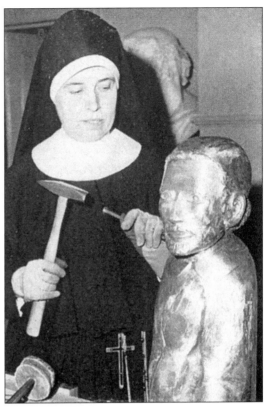

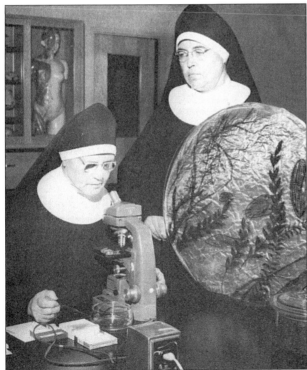

Sister Anna Catherine Lawlor (left) and Sister Theresa Angela Madden, long-time members of the Biology Department, inspect a specimen collection obtained from Morris County's Great Swamp. During the 1960s, the Port of New York Authority attempted to get a jetport built on the site of the Great Swamp. Sister Hildegarde Marie Mahoney and other area leaders successfully opposed this short-sighted proposal. (CSE Archive.)

Noted theologian Hans Küng visited the campus in 1969. He is seen here with the college's president, Sister Hildegarde Marie Mahoney. (CSE Archives.)

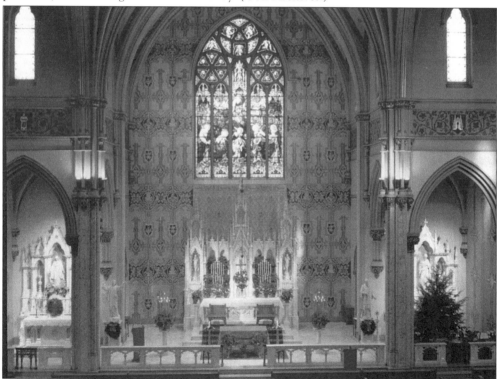

The majestic beauty of Holy Family Chapel never fails to awe and inspire worshippers. By the 1960s, the altar faced the congregation, a change that went into effect as a result of the Second Vatican Council. (Sisters of Charity Archives.)

One of the college's most distinguished and longest-serving professors, Sister Blanche Marie McEniry, made history "come alive" for generations of CSE students. In academic year 1965–66, she taught as a visiting professor at Al-Hikma University (below) in Iraq. In 1969, Sister Blanche Marie published *Three Score and Ten*, a history of the college's first 70 years. (CSE Archives.)

In its time, the Class Day tradition brought a lot of enjoyment to campus four times a year. Each class selected one day as its own, where all members, wearing class jackets and beanies, would stage a satirical skit attended by the rest of the college community. Afterwards, the class would go out together on its special day for dinner at a local restaurant. (CSE Archives.)

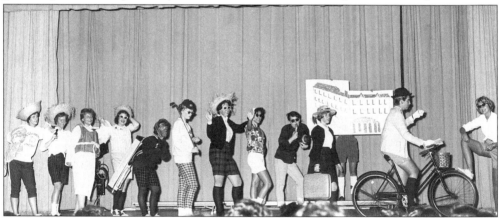

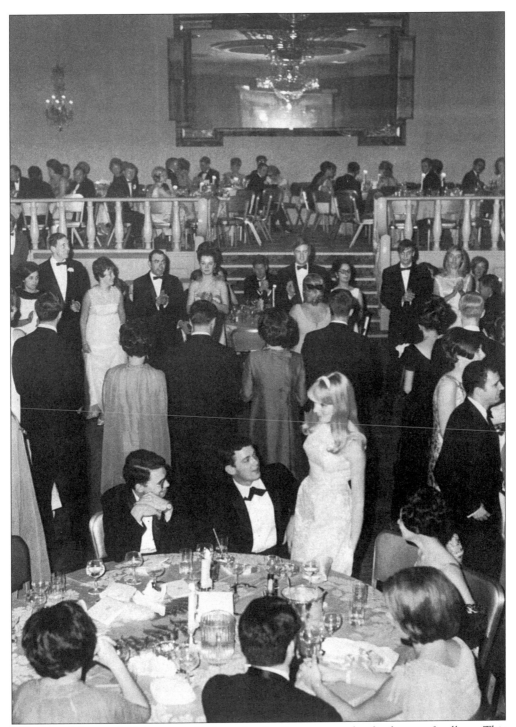

The annual Senior Ball lent an added touch of refinement to the final year of college. This picture was taken at the 1968 Senior Ball, held on December 27 at the Hotel Pierre in New York City. (CSE Archives.)

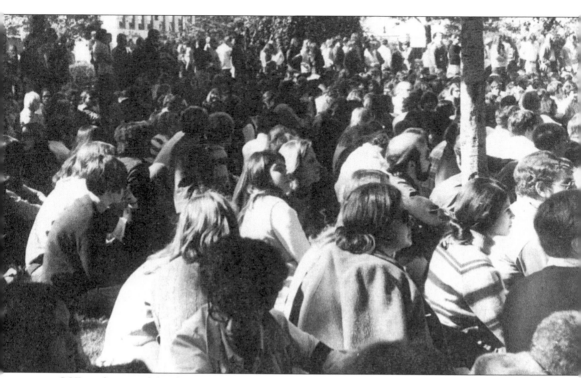

CSE students and faculty participated in the Vietnam War Moratorium of October 15, 1969. Classes were not officially canceled that day, but students and some faculty marched to the Morristown Green to join an anti-war rally. Later, lectures and small-group discussions about the war were held in Saint Joseph Hall. After that, a large crowd attended a poetry-reading and guitar-playing program held in the Octagon. An evening special-prayer assembly in Dodge Field, Madison, climaxed this memorable day. (CSE Archives.)

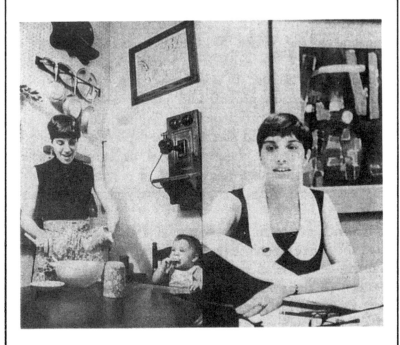

a woman's place is...

. . . in the home or in the office, wherever she chooses to make it. And these days, her choices are very wide.

By Law and by Bank Policy, a woman can apply for any job for which she is qualified — at the same rate of pay as anybody else, and with the same opportunities for training, personal growth, and promotion. Career women at Bankers Trust can go as far as their talents and ambition and performance will take them.

If you're a woman and you don't think you're getting a fair shake (that is, if you think you're being discriminated against because you are a woman), by all means please raise the issue.

Bring it up first with your supervisor — and if you're not happy with the response you get there, then go to your next higher supervisor or to your area Administrative Services Officer or to any one of the officers and trained counselors in the Personnel Relations Department

Pat Puglise King, CSE '63, shown above with daughter Kerry Ann in the kitchen of her New York Apartment and at her desk at Bankers Trust Company where she has recently been named an assistant treasurer, is one of a growing number of young women who opt for the dual role of wife-mother and career woman. The poster was used by Bankers Trust to inform its female employees that law and bank policy are aimed at protecting them from job discrimination on the basis of sex.

The Women's Movement came to the fore of national politics in the late 1960s. CSE already had been educating women to assume roles of leadership responsibility for 70 years. As such, it seems appropriate that Pat Puglise King, Class of 1963, an alumna and employee of Bankers Trust, was chosen as the subject of the above poster, which also includes Pat's daughter Kerry Ann. (CSE Archives.)

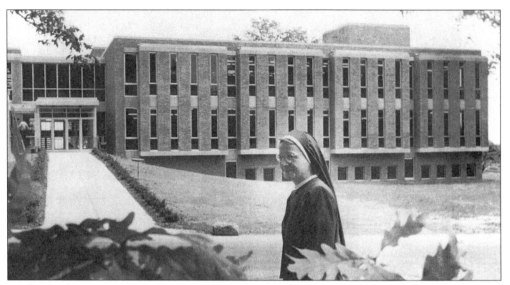

In the final year of the decade, the college opened its new library. The board of trustees unanimously passed a motion, which had emanated from a petition prepared by the college's faculty, students, and staff to name the new facility the Mahoney Library. This was in recognition of the outstanding leadership provided by CSE's president, Sister Hildegarde Marie Mahoney.

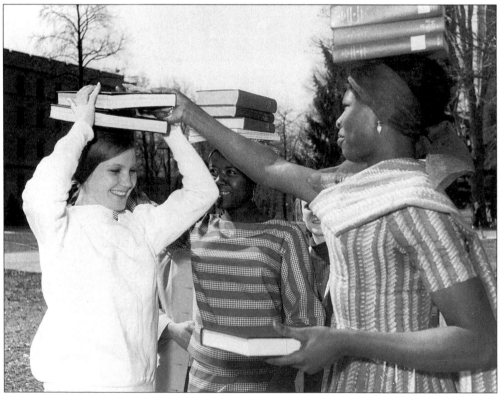

Students (above) assist in the massive task of carrying books from Santa Maria to their new domicile. (CSE Archives.)

Eight

1970–1979

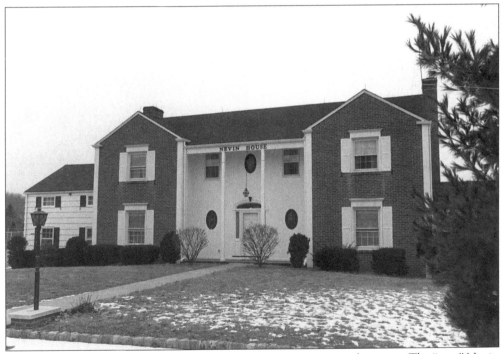

In the summer of 1970, the college acquired a building in an unusual manner. The "new" Nevin House, a gift from AlliedSignal Corporation, was moved by truck from Park Avenue onto the north end of the campus. The building initially served as the home-management house for the Home Economics Department. Nevin House is now the college president's residence. The Center for Independent Living for Aged/Handicapped (CILAH), a community outreach program, also maintains an office in this building. (CSE Archives.)

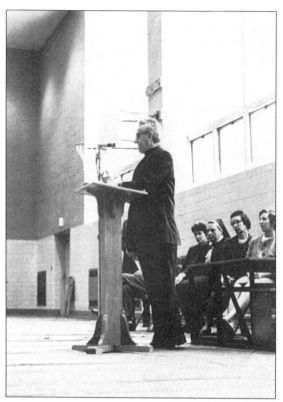

In the wake of the Kent State tragedy, a faculty panel (left) and about 400 students assembled in the gymnasium to discuss the morality of violence, the limits of revolt, and the right to dissent. Reverend Leonard Cassell, O.S.B., is pictured speaking. The Upward Bound Program, designed to expose disadvantaged high-school students to the educational and cultural opportunities available through attendance at college, drew volunteers from the ranks of CSE administrators, faculty, and students. Several Upward Bound youths (below) staged a campus fashion show in the fall of 1970. (CSE Archives.)

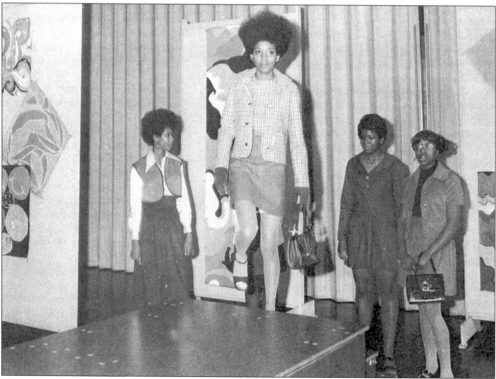

Sister Elizabeth Ann Maloney became the college's fourth president on July 1, 1971. Before this appointment, she had been a mathematics professor, assistant to the president, and dean of studies. Sister Elizabeth Ann's ten-year administration was a period of conscientious, compassionate, and constructive stewardship. During her tenure, the college expanded its teaching mission by establishing the Weekend College Program for female and male adult students. In 1981, Sister Elizabeth Ann left the college to become president and CEO of Saint Elizabeth Hospital in Elizabeth, New Jersey.

In the 1970s, the college continued to foster within its students a sense of responsibility for improving the lives of others. Converting that goal into concrete action took many forms and continued after graduation. Student-teacher Vicki Evariso (left), Class of 1978, works with children on a balance beam. Alumna Christine des Etangs Vurno (below), Class of 1963, instructs a client from the Center for Independent Living for Aged/ Handicapped (CILAH). (CSE Archives.)

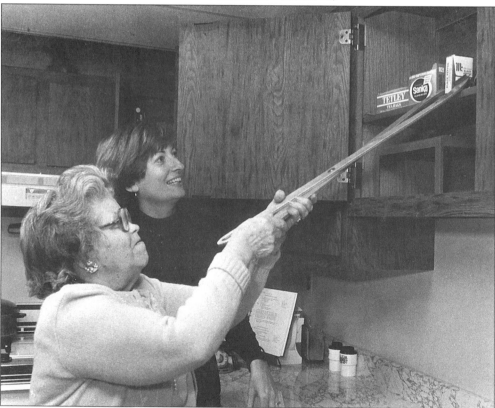

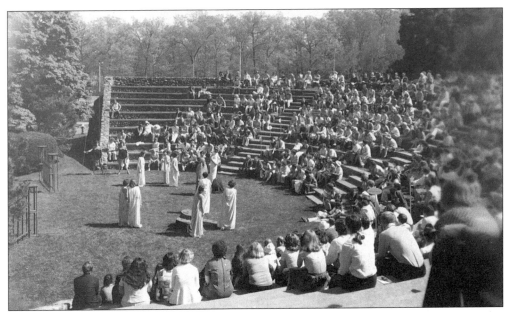

Like their predecessors, CSE students of the 1970s could watch or participate in a variety of play productions. The 1973 production (above) of *Iphigenia in Aulis* packed the Greek Theater. In the image below, long-time dramatics director Dorothy Barton (below) checks costumes for the 1971 production of *Cinderella*. (CSE Archives.)

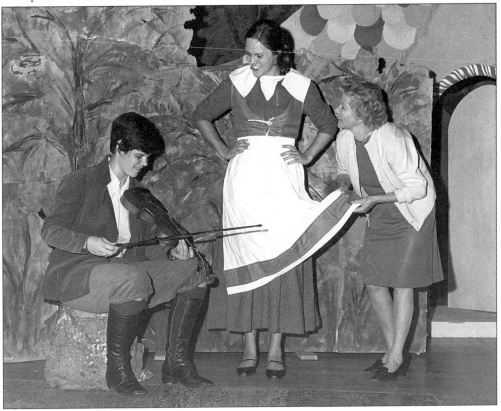

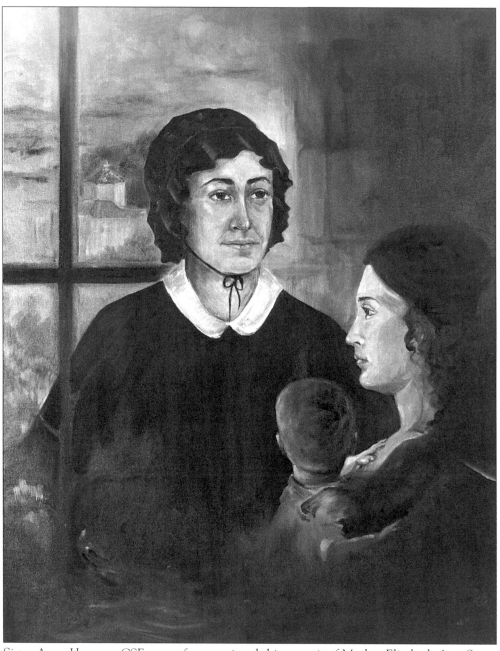

Sister Anne Haarer, a CSE art professor, painted this portrait of Mother Elizabeth Ann Seton in honor of her canonization. (Sisters of Charity Archives.)

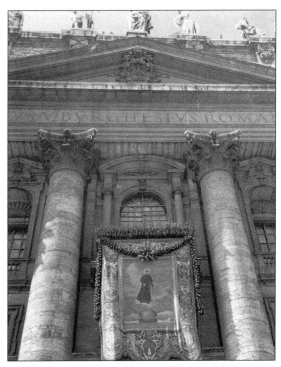

At right, an image of Saint Elizabeth Ann Seton (founder of the Sisters of Charity in the United States) hangs in Saint Peter's Square, the Vatican, in celebration of Mother Seton's canonization on September 14, 1975. In a private audience with Pope Paul VI in 1975, Sister Hildegarde Marie Mahoney is pictured below presenting a check from the six communities of the Federation of the Daughters of Elizabeth Ann Seton to benefit the starving peoples of the world. During this trip to Rome, Sister Hildegarde Marie was the first woman to read at a Papal Mass. (Sisters of Charity Archives.)

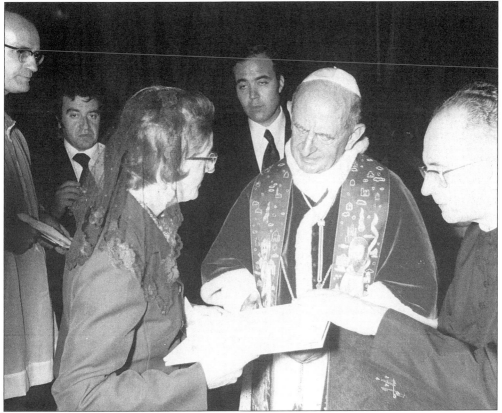

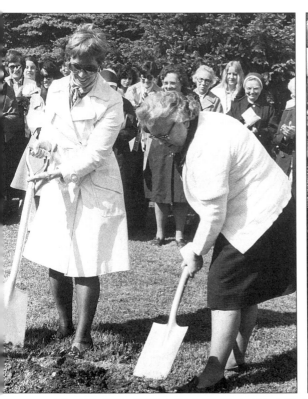

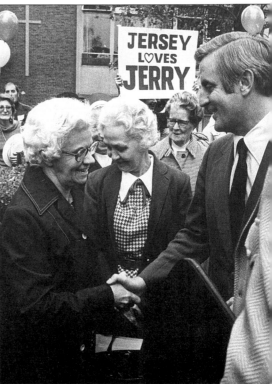

The college commemorated the nation's 1976 Bicentennial by planting a Liberty tree. Dr. Marcelle Chenard and Sister Elizabeth Ann Maloney (above left, left to right), of the Sociology Department, ceremonially began the digging. Democratic Vice-Presidential candidate Walter Mondale (above right) visited the campus during that year's campaign. A supportive crowd greeted him, but as the sign in the background indicates, Republican Presidential candidate Gerald Ford also had some support. (CSE Archives; Jim DelGiudice/CSE Archives.)

While remaining primarily a women's college for "traditional age" students, CSE, in the mid-1970s, began to serve the area's older students. Sister Mary Kathleen Hutchinson (right) directed the college's Center for Lifelong Learning, which reached out to local women who wanted to attend college part-time. In 1976, CSE initiated its Weekend College Program, which gave working women and men the opportunity to attend classes at nights and on Saturdays. Sister Marie Jonathan Bulisok (below) became the Weekend College's first director. (CSE Office of Communications and Marketing.)

The college has long had an excellent art curriculum, which emphasizes both art history and studio courses. In the latter group of offerings, students develop their talents in oils, water-color, calligraphy, sculpture, and ceramics. (CSE Archives.)

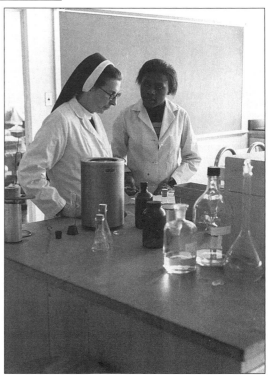

Sister Marian José Smith (right), a CSE chemistry professor for more than 50 years, assists a student with a laboratory experiment. (CSE Archives.)

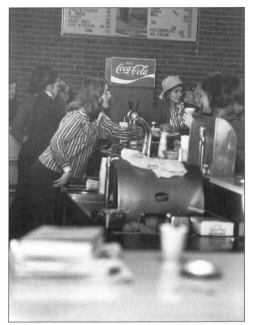

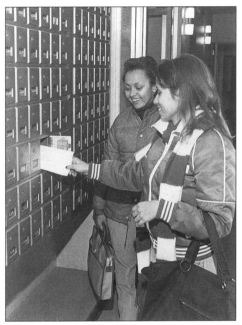

Although academic pursuits remained paramount, CSE students of the 1970s found time to relax and simply be themselves. Pictured are three typical images of campus life: students receive a welcomed letter from home, enjoy ice cream in the Snack Bar, and chat in their cars outside O'Connor Hall. (CSE Archives.)

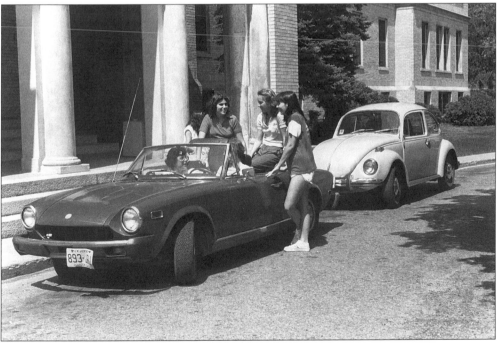

In the 1970s, the staff and faculty of the college began to include more lay persons. However, a few lay personnel already had been part of CSE's operations for many years, and their service continued in this decade. Three of the longest-serving lay members of the college community were two physical education professors, Elizabeth Ford (left) and Dorothy Donnelly (lower right), Class of 1942, as well as Julia Read (lower left), director of the Career Counseling and Placement Office. (CSE Archives.)

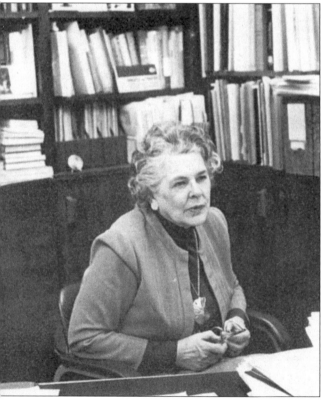

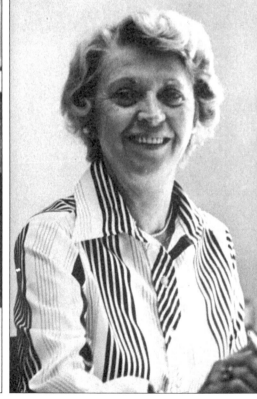

Nine

1980–1989

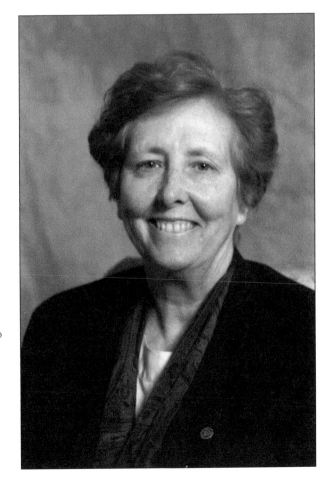

Sister Jacqueline Burns became the college's fifth president in July of 1981. Previously, she had been a history professor, assistant dean of studies, and dean of studies. During her 16 years as president, Sister Jacqueline furthered the college's commitment to multiculturalism, introduced significantly more technology into campus and academic life, and oversaw the inauguration of the college's first graduate programs. Her intelligent, energetic, and innovative leadership helped make possible a period of growth and sustained success in the college's recent history. (Kathy Cacicedo/CSE Archives.)

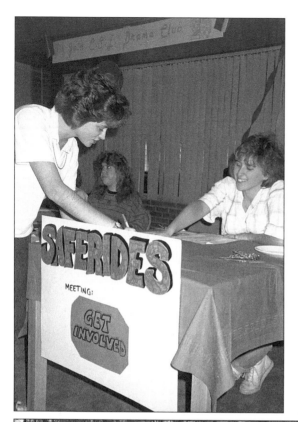

Commitment to service, exercised on behalf of classmates or of those in need among the larger community, remains a vital component of CSE's values and endeavors. Students (left) staff a "Saferides" project designed to halt drunk driving. CSE students (below) join students from nearby Fairleigh Dickinson University and Drew University in a Walk for the Hungry event. (Jim DelGiudice/CSE Archives.)

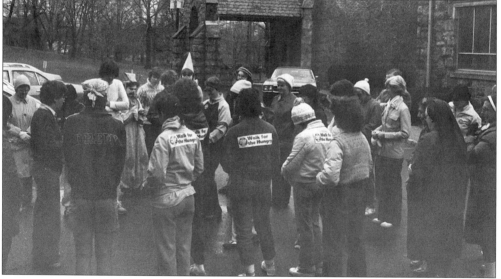

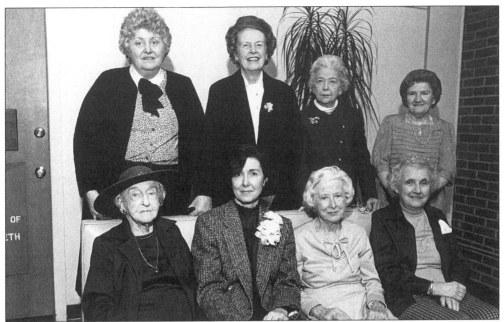

The Mother Xavier Award is the highest honor CSE confers upon alumnae. It has been presented each December on Founders Day, since 1956, to a college alumna of distinction and achievement who manifests the characteristics of a truly educated Christian woman. In this 1986 picture are eight Mother Xavier recipients. From left to right are as follows: (seated) Florence Wall (1913), Joyce Daly Margie (1962), the 1986 recipient, Marion A. Murphy (1931), and Catherine Sheehan McGuire (1931); (standing) Mary Margaret Mahoney O'Donnell (1954), Mary McKeon (1934), Janet Geraghty-Deutsch, M.D. (1943), and Anna Jackson (1936). (Jim DelGiudice/CSE Archives.)

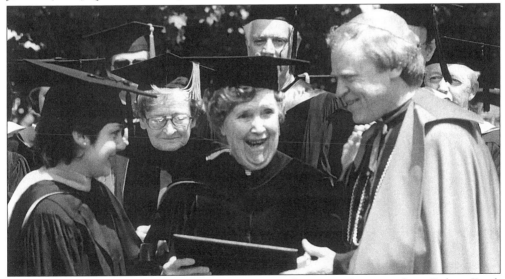

Mrs. Geraldine Riordan, Class of 1913, receives an honorary doctorate from Bishop Frank Rodimer at the 1983 Commencement ceremony. The Riordan family provided funds for the establishment of the Geraldine Doyle Riordan Center for Volunteer Services, a campus-based office that coordinates student-volunteer projects. (Jim DelGiudice/CSE Archives.)

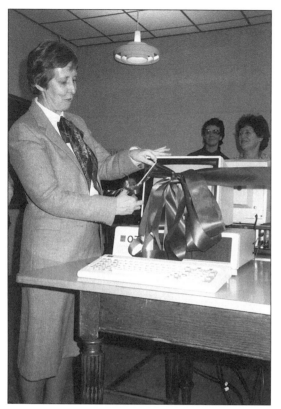

The college responded to the explosive growth of computer technology in the 1980s with a vigorous campaign to upgrade its facilities in this vital area. Sister Jacqueline Burns (left) presides over a ribbon-cutting ceremony marking the acquisition of a $15,000 grant to acquire additional hardware and software for its IBM microcomputer laboratory. Below, Sister Jacqueline looks on as Sister Joan Walters, chairperson of the Education Department, tests a new computer during the opening of CSE's Teacher Education Computer Laboratory. (Jim DelGiudice/CSE Archives.)

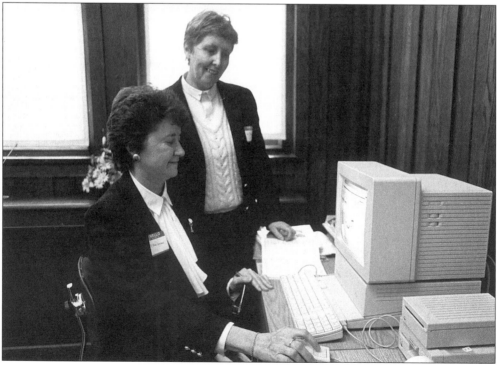

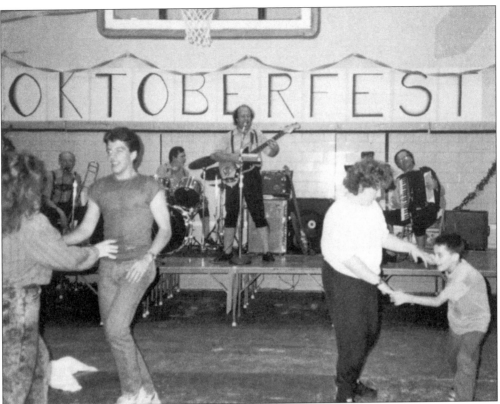

Oktoberfest at CSE has become an annual tradition, to which students' parents are cordially invited. Good music, good food, good conversation, and good cheer are enjoyed by all that attend this festive event. (CSE Archives.)

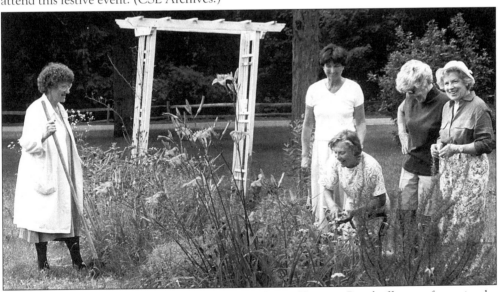

"Will's Belles" are volunteers who help Sister Agnes Vincent Rueshoff, a professor in the Philosophy Department, maintain the Shakespeare Garden. The idea for organizing the "Will's Belles" emerged during the 40th reunion of the Class of 1949. (Karen Fucito/CSE Archives.)

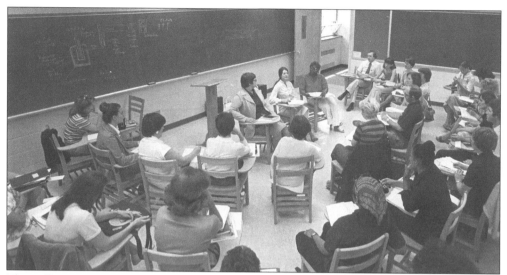

The college's "non-traditional" age student population grew dramatically in the 1980s. Sister Kathleen Flanagan (above) teaches a Religious Studies class in Weekend College (note that the Weekend College population includes male students). Students in CSE's Tuesday College Program (below), an initiative that enabled adult women students to schedule one day out of a busy week for classes, engage in thoughtful discussion. (Jim DelGiudice/CSE Archives; Van Burgess/CSE Archives.)

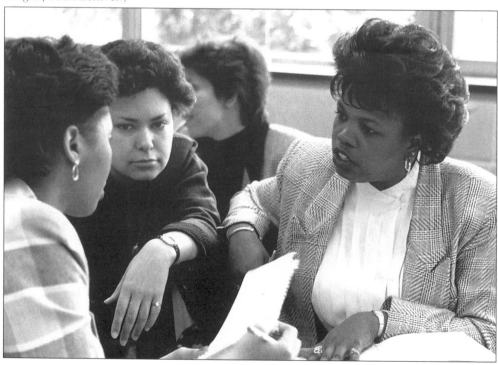

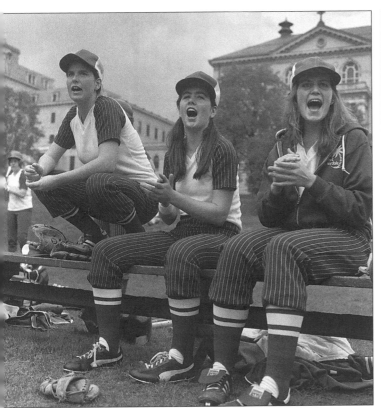

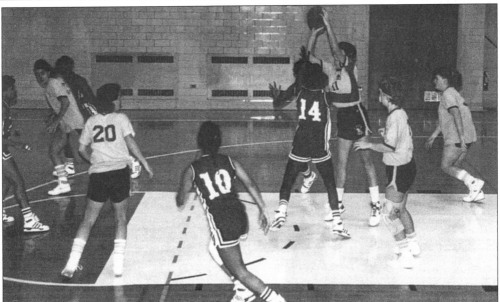

CSE sports its own "field of dreams," as members of the softball team (above left) cheer on teammates. The basketball team enjoyed much success in the 1980s, thanks largely to the remarkable skills of Terry Lockwood, Class of 1989 (above right), whose number 11 sports jersey has been retired at the College of Saint Elizabeth. (CSE Archives.)

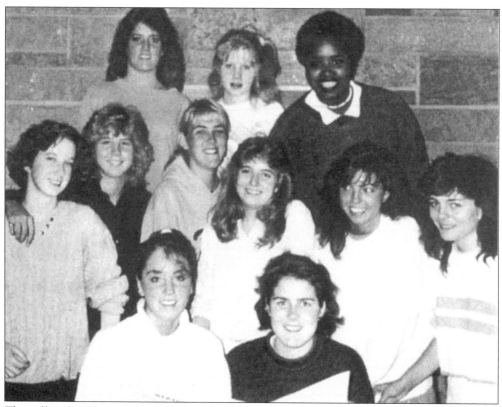

The college has always given strong encouragement to students to develop their writing talents. The staff of the 1988–89 school newspaper, the *Station*, is pictured above. In the 1980s, the *Station* replaced the *Pelican* as the campus newspaper. The *Sector* is the college's annual literary journal, which began publication in 1939. The journal consists of essays, poetry, and prose fiction written by students with creative flair. The editorial staff of the 1983 *Sector* is pictured below, with the journal's faculty moderator, Dr. Laura Winters of the English Department. (CSE Archives.)

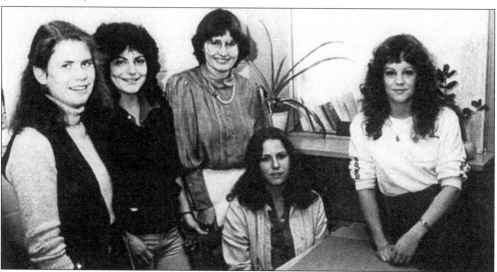

Ten

1990–1999

CSE's rigorous Nursing Program offers a bachelor of science in nursing degree to women who are already registered nurses. In 1995, Sister Jacqueline's family established the Burns Family Nursing Scholarship, which is given to qualified nursing students. (Judi Benvenuti/CSE Archives.)

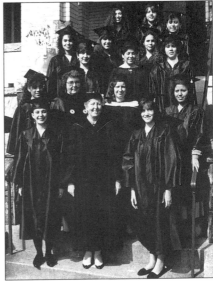

Sister Jacqueline Burns and Sister Jeanne Marie Gilligan, the dean of studies, stand proudly during Commencement 1992 with the first group of students to graduate from the college's Hispanic Leadership Program. This program was a pioneering effort to develop scholastic and leadership potential among Hispanic women. (Karen Fucito/CSE Archives.)

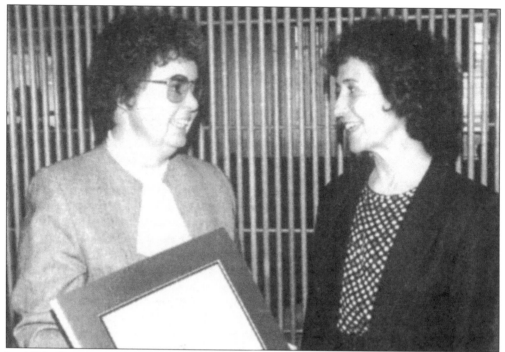

In 1990, History Department Chairperson Dr. Barbara Bari (right) was the Council for the Advancement and Support of Education (CASE) New Jersey Professor of the Year. Sister Jeanne Gilligan presented her with the engraved plaque that came with this prestigious award. CASE also named Dr. Bari a silver medalist in its national competition. (CSE Archives.)

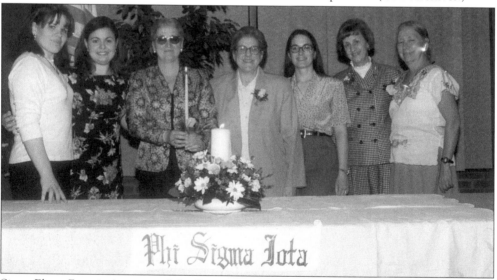

Sister Elena Francis Arminio, of the Foreign Language Department, served for many years as the director of the college's Honors Program, which provides special courses for the college's most academically advanced students. In the picture above, she stands in the center with members of Phi Sigma Iota, the foreign language honors society. Also pictured are Dr. Hannelore Hahn (third from left), Foreign Language Department chairperson, and Dr. Diane Monticone (second from right), a long-time French teacher at CSE. (CSE Archives.)

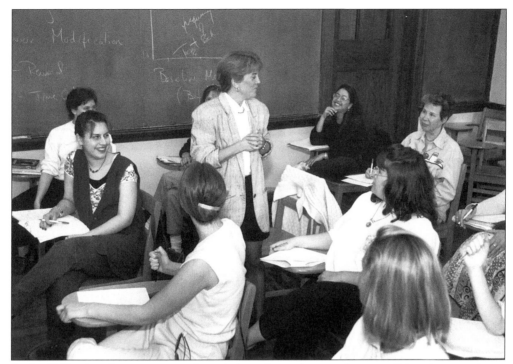

In the 1990s, day classes increasingly include traditional-age and non-traditional–age students, and the mixture works well for all concerned. Dr. Patricia Heindel (above), chairperson of the Psychology Department and director of the Graduate Program in Counseling Psychology, speaks to a class. The sign below expresses well-deserved praise for those women who returned to college even while juggling other roles—spouse, parent, breadwinner—in their lives. (Kathy Cacicedo/CSE Archives; Jim DelGiudice/CSE Archives.)

The college's 1991–92 equestrian team was led by national champion junior Stacey Roberts (left), Class of 1992. The world's most popular sport is now a vital part of the college's athletic program as three CSE Eagles (below) resonate the camaraderie and international flair of soccer. (CSE Archives; Stephen Spartana/CSE Office of Communications and Marketing.)

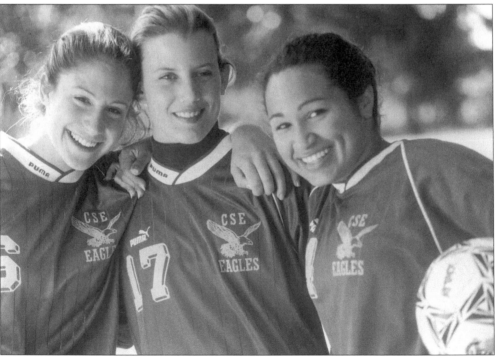

Five students (above) from Campus Ministry celebrated the Sacraments during Easter 1998. (CSE Office of Communications and Marketing.)

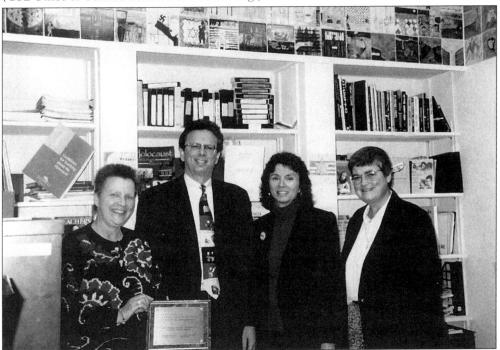

The college officially became a Holocaust Education Resource Center in 1994. This initiative emerged as an outgrowth of the annual Holocaust Remembrance Week programs developed by Dr. Harriet Sepinwall, of the Education Department, and Sister Kathleen Flanagan. Three years later, the college established a Holocaust Education Resource room in Santa Maria Hall. Present at the dedication of this room were the following, from left to right: Madison, New Jersey, school teacher Katherine Baltivik; Madison School Superintendent Lawrence Feinsod; Dr. Sepinwall; and Sister Kathleen Flanagan. (Erik Muench/CSE Office of Communications and Marketing.)

Thanks to the efforts of faculty and students alike, the college's century-long tradition of community service remains as vibrant as ever. Dr. Donna Howell (left), chairperson of the Biology Department, assists a youngster with a science experiment as part of a nearby After-School Enrichment Program in 1999. Students (below) participate in a home-renovation project sponsored by the Geraldine Doyle Riordan Center for Volunteer Services in 1997. (*The Echo*/Maria Bastone/CSE Office of Communications and Marketing.

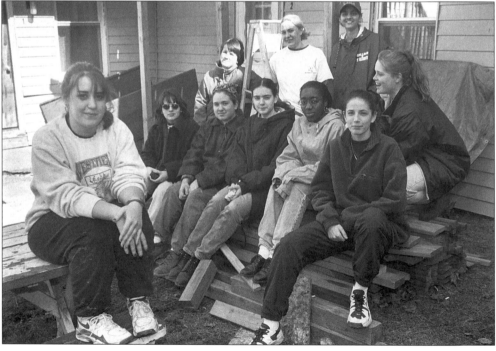

Dean of Students Maryclaire McGuire (right), who died unexpectedly on October 10, 1995, touched the lives of many students, faculty members, staff, and administrators. She was always accessible and had a limitless capacity to listen, challenge, affirm, and care. She will never be forgotten. (CSE Archives.)

A generous donation from Anita Falla, M.D., Class of 1943, enabled the college to purchase a Steinway concert grand piano in 1997. Seated at the piano is Dr. Teresa Walters, chairperson of the Music Department and an internationally acclaimed concert pianist. (Karen Fucito/*Daily Record*/CSE Office of Communications and Marketing.)

The Center for Theological and Spiritual Development at the College of Saint Elizabeth developed in response to the evolving needs of the Church as envisioned by the Second Vatican Council. The center offers excellent resources for the theological and spiritual development of the laity. Originating in 1982, the center's programs have grown steadily throughout the 1990s. The center's director is the Reverend Anthony Ciorra (left), also a Religious Studies professor at the college. His most recent annual Convocation attracted more than 3,000 participants. (Jim DelGiudice/CTSD; Karen Fucito/CTSD.)

The Center for Theological and Spiritual Development's Annual Convocation includes many of the most sought-after and inspiring speakers. They have included the following (clockwise from top left): Megan McKenna, Bishop Robert Morneau, Joyce Rupp, A.S.C., and Reverend Frank McNulty. (Karen Fucito/CTSD.)

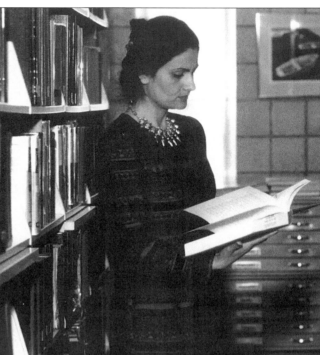
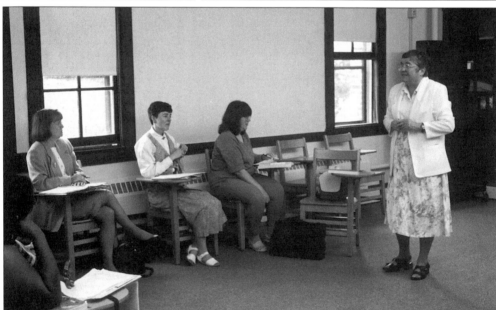

In the 1990s, the College of Saint Elizabeth developed and inaugurated seven graduate programs, including two in Education, Human Services Leadership and Educational Technology, as well as Counseling Psychology, Management, Foods and Nutrition, Health Care Management, and Theology. Sister Ellen Joyce (above) teaches graduate courses in the Theology Department as well as undergraduate courses in the Philosophy and Religious Studies Departments. (Jim DelGiudice/CSE Archives; Karen Fucito/CSE Office of Communications and Marketing.)

The students enrolled in the college's graduate programs find them challenging and rewarding. In turn, the presence of the graduate-student population has brought still greater enhancement to the intellectual life of the CSE campus. Below, Dr. Vincent Aniello teaches a graduate class in education. (Jim DelGiudice/CSE Office of Communications and Marketing.)

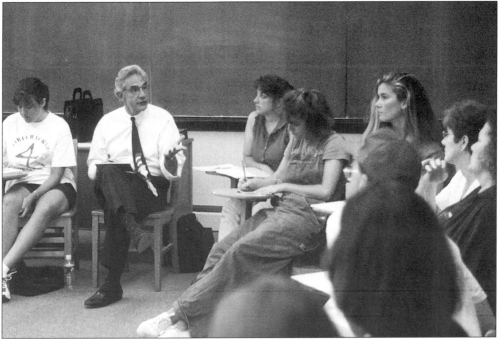

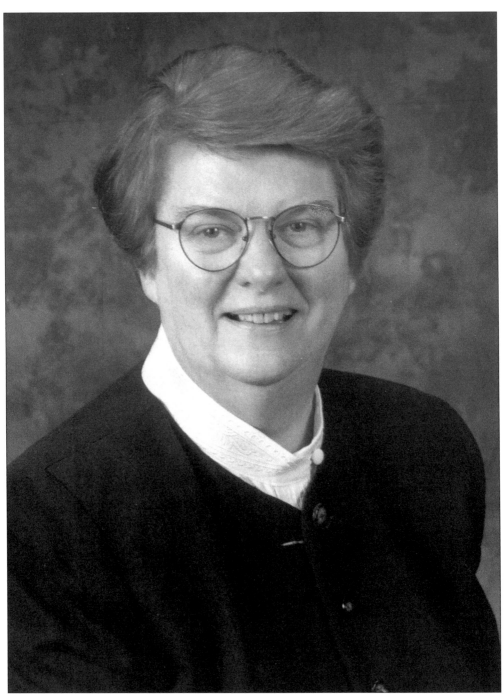

Sister Francis Raftery became the college's sixth president in July of 1997. Previously, she had been a professor of education at CSE and the provincial superior of the western province of the Sisters of Charity of Saint Elizabeth. Sister Francis is directing the 21st Century Plan, a sweeping campus remodeling and reorganization that will help usher in a second century of pedagogical, spiritual, and co-curricular vitality in the life of this institution. (Kathy Cacicedo/CSE Office of Communications and Marketing.)

Sister Francis Raftery's inauguration on April 21, 1998, was a day of colorful pageantry and a renewal of institution-wide commitment to shape the future for the college in the new millennium. (Kathy Cacicedo/CSE Office of Communication and Marketing.)

Betty Ann Clarken, Class of 1956 (above left), was for many alumnae the human heart and soul of the Alumnae Association during the 20 years (1978–98) she served as its executive director. Her dedication serves as a hallmark for alumni directors everywhere. The present executive director of the Alumnae Association is Debbie Martin (above right). (CSE Archives.)

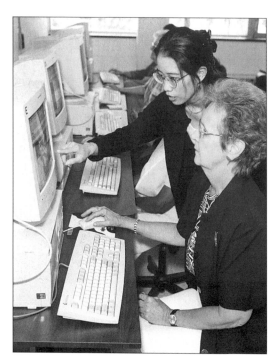

The college responded to the growing need for computer literacy in several ways. It established a computer science major, offered administratively out of the Mathematics Department. In addition, computer-instruction sessions were held for the benefit of administrators and faculty. In the image to the left, Dr. Johanna Glazewski, the college's dean of studies in the early 1970s and again since 1994, gets a computer lesson from Ivy Lim, the Academic Computing Director, in 1997. A million-dollar Higher Education Facilities Grant from the State of New Jersey enabled CSE to enter into a partnership with Lucent Technologies. Lucent Technologies developed, designed, and installed a uniform cable infrastructure linking residence halls, instructional areas, and faculty offices in a voice, video, and data network. (Jim DelGiudice/CSE Office of Communications and Marketing.)

The first bi-annual Catholic Woman of Achievement Awards were given on October 28, 1995, to the following (clockwise from top): Sue C. Regan, Kent Manahan, Cathy DiFiore, and Sister M. Christine Reyelt. This award honors women whose achievements mark them as leaders in their professional or civic lives, and whose personal ethics, faith, and Catholic values inform their activities. (Harry Simpson/CSE Office of Communications and Marketing.)

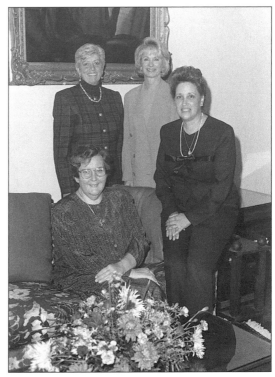

For its first centennial-related event, the college invited Sister Helen Prejean, C.S.J.(above), to bring her mission to abolish capital punishment into the area in April 1999. She spoke before an audience of more than 700 people at the Madison Hotel before coming onto campus to engage in further discussion of this issue, to sign copies of her book *Dead Man Walking*, and to participate in Vespers. (Kathy Cacicedo/CSE Office of Communications and Marketing.)

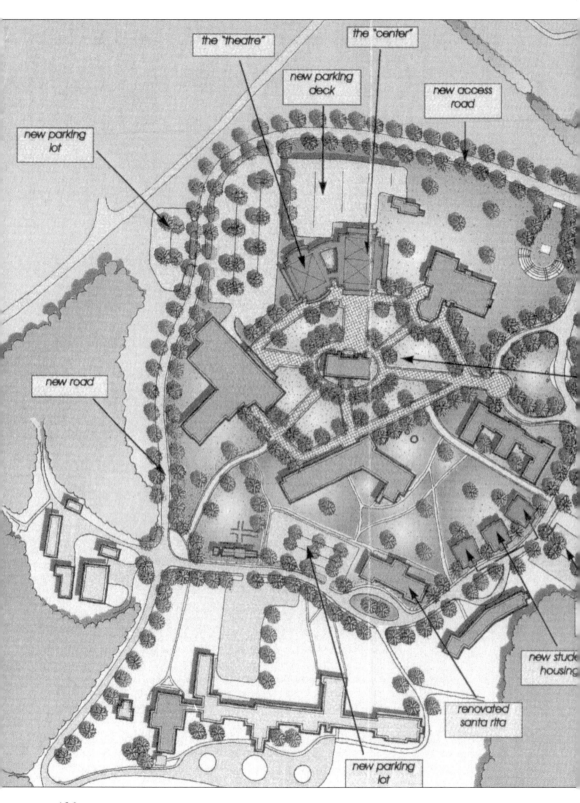

the "theatre"

the "center"

new parking deck

new access road

new parking lot

new road

new stude housing

renovated santa rita

new parking lot

Under Sister Francis Raftery's leadership, and with the approval of the board of trustees, the college's plans for the succeeding years are well underway. Pictured to the left is a blueprint depicting the end product of an ambitious 15-year building and renovation campaign scheduled to begin in the summer of 1999. [The restructured campus will have a new college "center," designed to visibly express CSE's commitment to its future, its changing student populations, and its carefully-designed strategic plan. The "center" will provide facilities for adult undergraduate and graduate programs, the Center for Spiritual and Theological Development, fine and performing arts, and community enrichment programs open to the public.] (H2L2/CSE Office of Communications and Marketing.)

Visiting Rockefeller Center, CSE students Jessica Brown and Darcy Lemaire (above) look ahead with confidence to the global society in which they will live. Like all the graduates at the College of Saint Elizabeth's Centennial Commencement (below), they have been well prepared for the challenges and opportunities of the next millennium. (Stephen Spartana/CSE Office of Communications and Marketing; Kathy Cacicedo/CSE Office of Communications and Marketing.)

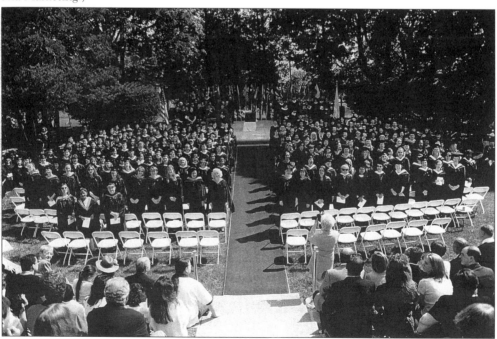